TURBINE
RACING
IN SEATTLE

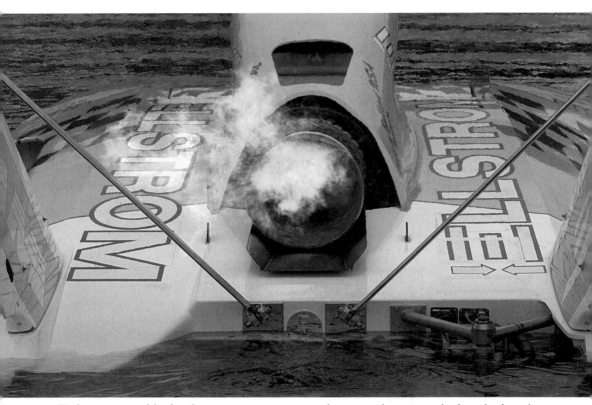

Turbine-powered hydroplanes may not generate the noise that piston hydros do, but they are every bit as exciting. Nate Brown fires up the *U-16 Miss Elam Plus* on his way to victory in the 2001 General Motors Cup. (Courtesy of F. Pierce Williams.)

TURBINE RACING
IN SEATTLE

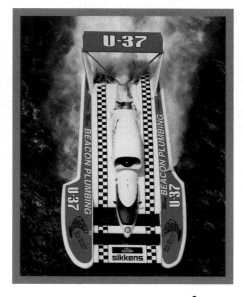

David D. Williams

ARCADIA
PUBLISHING

Published by Arcadia Publishing
Charleston SC, Chicago IL, Portsmouth NH, San Francisco CA

Printed in the United States of America

Library of Congress Catalog Card Number: 2007921322

For all general information contact Arcadia Publishing at:
Telephone 843-853-2070
Fax 843-853-0044
E-mail sales@arcadiapublishing.com
For customer service and orders:
Toll-Free 1-888-313-2665

Visit us on the Internet at www.arcadiapublishing.com

CONTENTS

ACKNOWLEDGMENTS

In an age when professional sports stars are paid tens of millions of dollars to play football, baseball, and soccer, it is refreshing to see a "professional sport" where most of the competitors are willing to compete out of sheer love of the game. That's the way unlimited hydroplane racing is. Some of the drivers and a few crewmen draw a salary, but the vast majority of people working in the pits and risking their lives in the cockpits are doing it out of love of the game. For that reason, I dedicate this book to all of the hardworking volunteers who keep this sport going.

—David D. Williams

Visit the Hydroplane and Raceboat Museum at:
5917 South 196th Street
Kent, WA 98032
Or log on to www.thunderboats.org

Many of the photographs in this book were taken by the incomparable Bill Osborne. His talent for catching the beauty, power, and grace of unlimited racing is unmatched. To see more of his work, log on to www.billophoto.com.

Photographs not provided by Bill Osborne come from the extraordinary photograph collection of the Hydroplane and Raceboat Museum. Over the last 20 years, tens of thousands of photographs have been donated to the museum. Some were clearly marked by the original photographer; many were not. In preparing this book, I have attempted to identify and give proper credit to every photographer. I am continuing to research the origin of any unidentified photographer, and where possible, the photographer will be credited in future editions of this work.

INTRODUCTION

Hydroplane racing has been an important part of the Seattle sporting scene for over 50 years. The roaring, bouncing, fire-breathing hydros captured the attention of Seattleites in the early 1950s and have never let go. In the mid-1980s, the sport began to change. The loud, gutsy, piston aircraft motors that powered the hydros were replaced by quieter, more sophisticated turbine engines. By 1985, the sport was totally dominated by turbine-powered boats. For many fans, the history of the sport is easily divided into two distinct eras, the piston era, from 1950 to 1984, and the turbine era, from 1985 to the present. The piston era was covered in my previous book, *Hydroplane Racing in Seattle*. This new book tackles the turbine era.

Before we begin to talk about turbine racing, I want to answer one basic question. What is a turbine? Quite simply, a turbine is a rotating device that extracts energy from a moving fluid. (The word turbine comes from the Latin *turbinis*, meaning vortex.) The simplest turbine that comes to mind is a child's pinwheel. The blades of the pinwheel extract energy from the moving air (remember, to physicists, air is considered a fluid).

Most people understand how a piston engine works but feel that a turbine engine must be far more complicated and difficult to understand. In fact, nothing could be further from the truth. The supercharged Merlin engine with all of its valves, cams, and drive gears has more than 4,000 moving parts and is just about the most complicated motor ever built. A modern turbine has only a few moving parts and is really quite easy to understand. Start by closing your eyes and imagine that you have a Bic lighter, a squirt gun filled with gas, a pinwheel, and a large paper soft drink cup (like you get when you go to the movies) laying on a table in front of you. With your imagination, knock out the bottom of the cup, and place your pinwheel at the narrow end of the cup. Now just about two inches in front of the pinwheel, drill an imaginary hole and insert the lighter. Next drill another imaginary hole two inches ahead of the lighter and insert the squirt gun. Now carefully blow into the big open end of the cup, then start squirting the squirt gun and flick the lighter on. As the air carries the gasoline into the lighter, the gas ignites, causing it to expand dramatically and rush by the pinwheel. The pinwheel will spin furiously. Now attach a prop shaft to the spinning pinwheel and you have a simplified model of a gas turbine. In the real world, the parts are all made of metal and the paper cup is called an inlet. The gas-filled squirt gun is called a fuel nozzle, the lighter is called an igniter, and the pinwheel is called the power takeoff wheel.

Today's unlimited hydroplanes use a 600-pound, 2,850-horsepower Lycoming T-55 L-7 engine from Vietnam-era Chinook helicopters, but it didn't start that way. For the entire story of the evolution of unlimited turbine racing, read on.

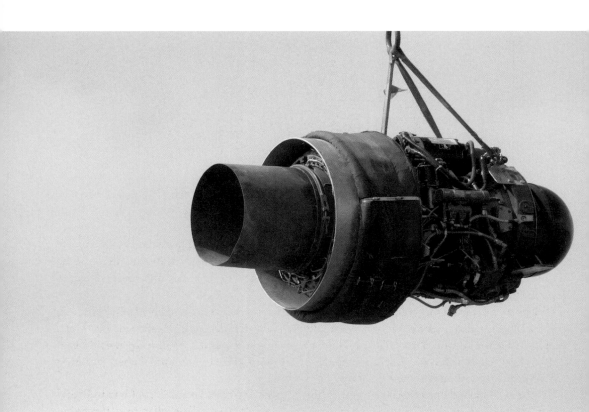

The lightweight, powerful Lycoming T-55 L-7 turbine is perfectly suited for unlimited hydroplane racing. Weighing approximately 600 pounds and putting out 2,850 horsepower, it has dominated unlimited racing for two decades.

1

1 9 6 8 – 1 9 7 4

THE INNOVATORS

The start of the turbine era in unlimited hydroplane racing can be pinpointed to January 5, 1968. That was the date Harry Volpi, chairman of the Safety and Technical Committee of the Unlimited Commission, signed the "permission to build form" for Don Edwards and the *Golden Komotion* turbine hydroplane.

The 30-foot, 2-inch–long and 11-foot-wide aluminum boat was designed and built by Rich Hallett. She was patterned after the world's record-holding jet boat *Hustler*, which Hallett had designed and built for Lee Taylor. The *Golden Komotion*'s power plant was a 5,000-horsepower Allison T-40. Edwards was a veteran drag boat racer who had won a number of national championships with his Hallett-built, automotive-powered drag boats.

As the boat neared completion, a sponsorship deal was negotiated with Andy Granatelli and the STP Corporation. Reluctantly, Edwards turned the $50,000 deal down when he realized that his boat would not be finished in time for the 1969 season.

Edwards pushed ahead, hoping to make the final race of the year in September. In a late night test firing, something went wrong. The engines exploded in a ball of fire and were destroyed. Edwards was out of money and the team folded. The boat never hit the water.

On the other side of the country, a small group of racers in North Tonawanda, New York, were working on their own turbine project. Paul Cozard purchased Guy Lombardo's *Tempo VII* and replaced the Allison engine with a GE T-58 from a Sikorsky Sea King helicopter. The 1,200-horsepower engine weighed less than 400 pounds and was mounted in front of the driver with the exhaust going into a long duct on the right side of the cockpit.

The boat was renamed *Turbine-1* and was driven by Ace Englert. The project never panned out, and the boat was eventually sold to the Guy Lombardo Museum in London, Ontario, and restored to its Allison-powered configuration.

In the early 1970s, two far more serious efforts to make turbine power a reality were mounted.

In Michigan, Jim Herrington and the *Mariner Too* team had the 1964 conventional *Mariner Too* rebuilt as a cabover with a hybrid Westinghouse turbine engine. The boat tested in late 1971 with Fred Alter driving. After the test, Herrington ordered a new, larger boat from Michigan boatbuilder Les Staduacher.

In Seattle, an even more impressive effort was underway. Jim Clapp, heir to the Warehouser timber fortune, teamed up with Ron Jones to build a revolutionary cabover, pickle-fork hydroplane powered by twin 1,700-horsepower Lycoming T-53 turbines. A model of the boat, along with details of the team, was unveiled at a press conference in Seattle on January 24, 1973.

Clapp's boat, named the *U-95*, was a sophisticated effort that borrowed heavily from the aviation industry. The team was lead by the talented and capable Chuck Lyford III. Chuck was well known in both the airplane and hydro communities. He had experience as a crewman on the *Thriftway Too*; he was a former national champion in the seven-liter limited class and also piloted the Bardahl Special P-51 racing Mustang.

Another Bardahl veteran, Billy Schumacher, was originally slated to drive the *U-95*, but a disagreement between Schumacher and Clapp led to a driver switch early in the project, and Leif Borgersen ended up in the cockpit.

There was a friendly competition between the *U-95* and the Herrington team to see who would be the first to make it to an actual race. The *U-95*'s goal was the 1973 Gold Cup in Tri-Cities, Washington, in July. The Herrington team was shooting for September's National Champions Regatta in Detroit.

The *U-95* team missed the July date, but a few weeks later, on August 5, the beautiful white boat was unveiled at Seafair in Seattle. However, the boat was only there for a display. Even though the *U-95* was placed in the water for christening, she didn't run.

Herrington's boat, named *Miss Lapeer*, was finished in time for the 1973 Detroit National Champions Race on September 9. The boat ran a few exhibition laps with Fred Alter driving. The *Lapeer*'s times, in the mid-70-mile-per-hour range, fell far short of the speed necessary to qualify. The *Lapeer* never ran again.

Three days later, on Wednesday, September 12, the *U-95* tested in Seattle with Leif Borgersen driving. The *U-95* managed only one and a half laps before a dashboard warning light forced Borgersen to shut the boat down. The test was brief but impressive.

A few months after the *U-95*'s first run, Jim Clapp passed away. His widow, Pam, took over as owner.

On May 31, 1974, the *U-95* qualified for the Champion Spark Plug Regatta in Miami, at a modest 106.132 miles per hour, to become the first turbine-powered boat to make it into an unlimited race. Borgersen drove the boat to a respectable fifth-place finish.

Two weeks later, at Owensboro, Kentucky, the *U-95* rocked the piston-powered establishment by claiming the fastest qualifier spot with a 119.046-miles-per-hour average.

In Tri-Cites in July, the *U-95* won her first heat by beating the defending national champion, *Pay N' Pak*. Borgersen looked poised to win his first race, but the *U-95* was damaged in a collision with Bill Muncey and the *Atlas Van Lines* during the final heat and wound up fourth.

The following week in Seattle, the *U-95* blew an engine and sank. Pam Clapp retired from racing, and the *U-95* was sold to another owner, who replaced the turbine with an Allison.

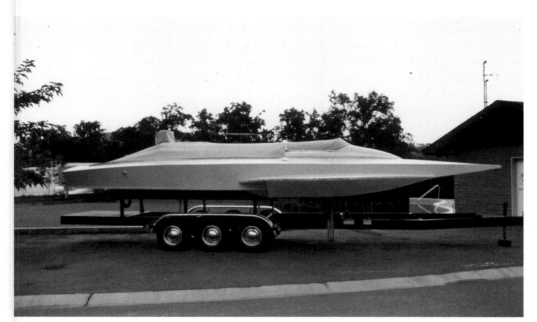

Many hydro fans thought that the *Golden Komotion* was a "phantom boat" that never existed, but as this photograph proves, she was a real boat. (From the collection of Don Edwards.)

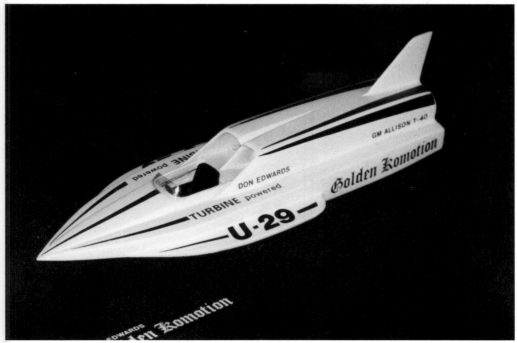

The *Golden Komotion* was never finished, but this model shows what it would have looked like if it had been completed. (From the collection of Don Edwards.)

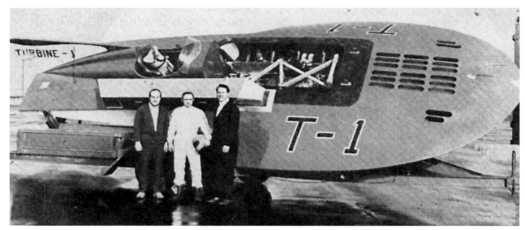

The *Tempo VII* was built in 1955 for Guy Lombardo. By 1970, she was owned by Paul Cozard and was converted to turbine power. Notice the air inlets in the deck and the long exhaust duct next to the cockpit. (Courtesy of Edward W. Barczak.)

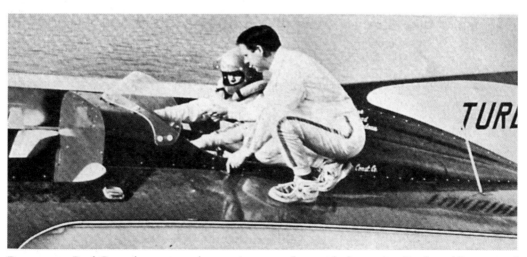

Boat owner Paul Cozard goes over the starting procedure with driver Ace Englert. (Courtesy of Edward W. Barczak.)

1963–1974: THE INNOVATORS

Like the *Turbine-1*, the *Mariner Too* was an Allison-powered hull that was reconfigured to accommodate a turbine engine. (Courtesy of Sandy Ross.)

Fred Alter prepares to test fire the turbine motor in the *Mariner Too*. (Courtesy of Sandy Ross.)

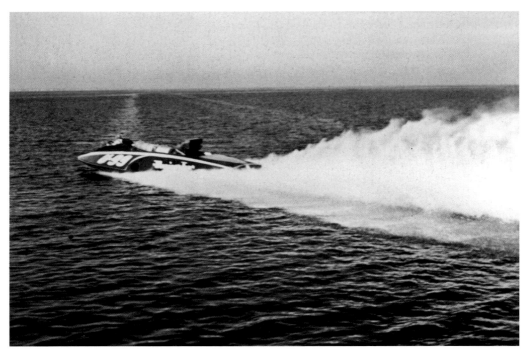

The *Mariner Too* tested quite successfully in 1971. (Courtesy of Sandy Ross.)

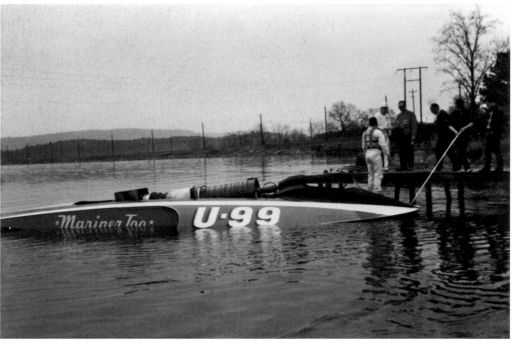

Fred Alter brings the *Mariner Too* back to the dock after a successful test run. (Courtesy of Sandy Ross.)

1963–1974: THE INNOVATORS

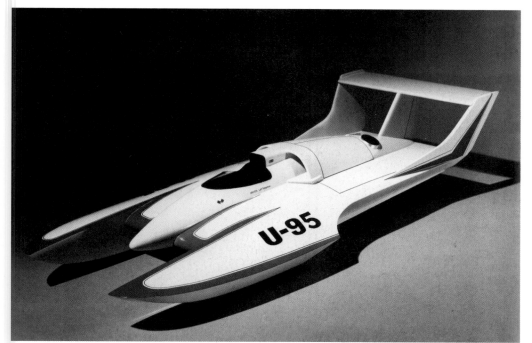

The *U-95* was a well-funded, well-thought-out project. This photograph of a scale model of the boat was part of the official press release that was issued in January 1973.

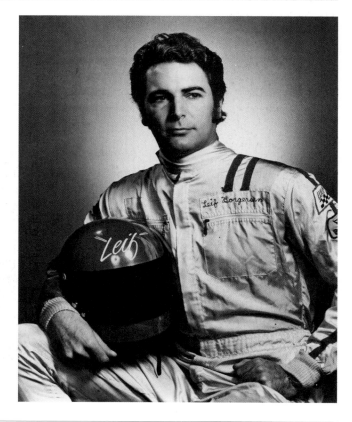

Leif Borgersen was selected to drive the *U-95* and holds the distinction of being the first driver to enter competition in a turbine-powered hydroplane.

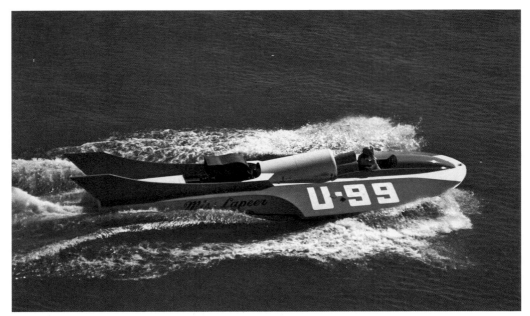

Jim Herrington's *Miss Lapeer* was unveiled at the 1973 National Champions Regatta in Detroit. The boat attracted lots of attention, but its speeds were unimpressive. (Courtesy of Bill Osborne.)

With Fred Alter driving, the *Miss Lapeer* made a few laps in the mid-70-mile-per-hour range, returned to the dock, and has never been run again. The boat is currently housed in David Bartush's Detroit Hydroplane Museum. (Courtesy of Sandy Ross.)

1963–1974: THE INNOVATORS

Chuck Lyford gives instructions to Leif Borgersen prior to an early test run. Notice the aircraft-style steering yoke instead of the traditional steering wheel.

The launching of the *U-95* was a major event that attracted attention for the entire racing community. Here world land speed record-holder Craig Breedlove (left) talks to Leif Borgersen (right).

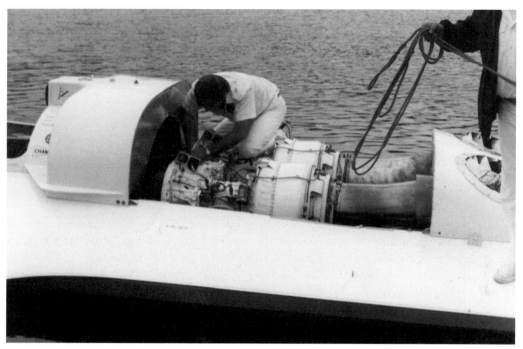

The *U-95* was powered by two side-by-side Lycoming T-53s and a unique "T" drive gearbox.

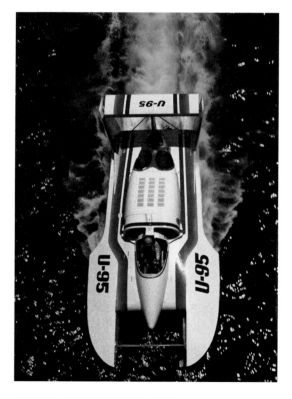

The *U-95* was beautiful, fast, and very quiet. She never won a race, but she proved that turbine power had a future in unlimited racing. (Courtesy of Bill Osborne.)

1963–1974: THE INNOVATORS

2

1975–1985

JIM LUCERO

No one person deserves more credit for introducing turbine power plants to unlimited racing than Jim Lucero. Lucero grew up in Seattle watching hydroplane racing. While he was still a young engineering student, he took a part-time job working as a parking attendant at a building that was owned by C. A. Lyford II. Soon Jim met C. A.'s son, Chuck Lyford III, who owned and piloted the *Bardahl Special*, a modified P-51 pylon racer. Jim was invited to work on Chuck's plane, where he met the legendary Merlin motor wizard Dwight Thorn. In late 1965, Jim went to work for the Notre Dame Unlimited team. After the disastrous 1966 season, Jim was hired by Lee Schoenith and worked on a couple of boats, including the innovative "bat winged" *Smirnoff*. In 1970, Jim took a stab at boat designing and drew up plans for a radical twin automotive-powered "cabover" *Atlas Van Lines* for Bob Fendler. In the middle of the 1970 season, Jim landed with Dave Heerensperger and the *Pay N' Pak*.

In Heerensperger, Lucero found a team owner who shared his total commitment for excellence and had the resources to back up his vision. Together Heerensperger and Lucero became a force to be reckoned with, winning the National Championship three years in a row: 1973, 1974, and 1975.

At the end of the 1975 season, Heerensperger surprised everybody (including Lucero) by retiring from unlimited racing and selling his entire team to Bill Muncey.

Muncey and Lucero picked right up where Heerensperger and Lucero left off, winning three more national championships in 1976, 1978, and 1979.

By the end of the 1979 season, Lucero had won six out of the last seven national championships. The challenge of running a successful Merlin-powered race team was becoming routine. Jim wanted something new; he wanted to run a turbine. He offered the chance to Muncey, but Muncey elected to stick with the tried-and-true Merlins.

Dave Heerensperger was intrigued by Lucero's ideas and agreed to reenter the sport with a new Lucero-designed hull powered by a Lycoming T-55 L-7 turbine. Jim's close friend and talented inboard racer John Walters was asked to drive.

The T-55 seemed a perfect fit for an unlimited hydro, weighing only 600 pounds but putting out an incredible 2,850 horsepower.

The new turbine *Pay N' Pak* debuted at Tri-Cites in July 1980 and looked incredibly fast, but a horrific blow-over accident during pre-race testing put the *Pak* out of the race.

The following year, a repaired and redesigned *Pay N' Pak* took second place in the opening race of the season. The *Pak* struggled through the rest of 1981, qualifying fast but never cracking the winner's circle.

The last race of 1981 ended in tragedy, when Bill Muncey was killed in a blow-over accident while driving the *Atlas Van Lines* in Acapulco, Mexico. In the second race of 1982—Thunder in the Park in Geneva, New York—Walters and the *Pak* qualified fastest and went on to win the race, claiming the honor of being the first turbine boat to win a race. One month later, the sport suffered a devastating loss when *Miss Budweiser* driver Dean Chenoweth was killed while attempting to qualify for the Columbia Cup in Tri-Cities, Washington.

In Seattle that year, the *Pay N' Pak* collided with the old *U-95* (renamed *Executone*) in heat 1-B. The frightening accident severely injured John Walters. This accident, coming so close on the heels of Bill Muncey's fatal crash in Acapulco and Dean Chenoweth's death the previous week in Tri-Cities, prompted Heerensperger to retire again.

With Heerensperger's retirement, there would be no turbine teams in 1983. But Lucero didn't give up on racing. He became a partner in Muncey Enterprises and worked with Bill Muncey's widow, Fran, to campaign the *Atlas Van Lines* for the 1983 season. With Chip Hanauer driving, the *Atlas* won both the Gold Cup and the National Championship. Lucero, always an innovator, installed a reinforced "crash cockpit" on the 1983 *Atlas* that allowed Chip to wear a shoulder harness that would keep him in the boat in case of an accident.

In 1984, Lucero was incredibly busy. He built a Merlin-powered boat for Bill Wurster and Executone, and he built a turbine-powered boat for Bob Taylor, sponsored by Miller Brewing, named the *Lite All Star*. The *Lite All Star* was powered by a GE T-64 turbine. Lucero also built a brand-new turbine boat for Atlas Van Lines and Muncey Enterprises.

The new *Atlas* was very fast, earning top qualifier marks in seven out of eight races and winning the 1984 Gold Cup in Tri-Cities as well as the Governor's Cup in Madison, Indiana. But the boat suffered "new boat blues" and failed to finish a number of heats, dropping her to fourth in National High Points. It was *Atlas*'s last year in the sport.

Another Lucero turbine, the former *Pay N' Pak* backup boat, was renamed *Miss Tosti Asti* and won the 1984 World Championship Race in Houston, Texas.

At the end of 1984, Bob Taylor retired from unlimited racing and Muncey Enterprises picked up the Miller sponsorship. *Miss Budweiser* owner Bernie Little bought the *Lite All Star* hull and began to tinker with his own turbine team.

In 1985, the combination of Muncey, Lucero, Hanauer, and Miller was awesome, winning five of nine races and capturing both the Gold Cup and National High Points Championship. Along the way, Hanauer and Miller set half a dozen world records, including a one lap of 153.061 miles per hour at Tri-Cities.

A new, lighter Lucero-designed *Miller* was ordered for 1986, and construction began during the off-season. From the outside, it looked like Muncey and Lucero had the world by the tail, but appearances can be deceiving. Behind closed doors, there was tremendous friction between Jim and Fran, and it all came to a head just six weeks before the start of the 1986 season.

In addition to crewing on Bill Muncey's *Atlas Van Lines*, John Walters helped Jim Lucero build the 1980 *Pay N' Pak* and was tapped to drive the revolutionary new boat.

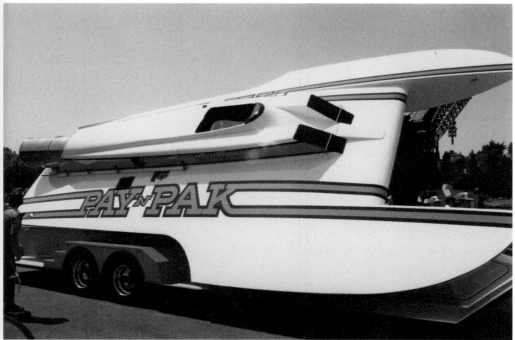

The new *Pay N' Pak* was christened in Seattle in late July 1980, a few days before the Tri-Cities race.

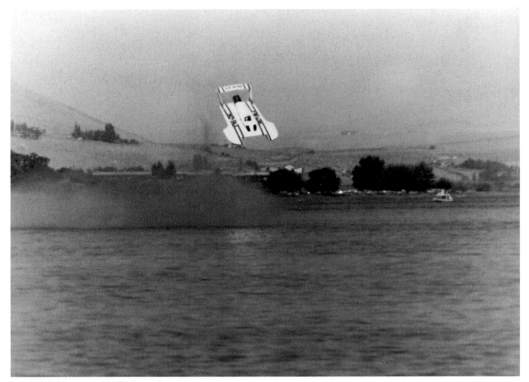

Pay N' Pak's debut in Tri-Cities ended in a disastrous pre-race crash. (Courtesy of Rich Ormbreck.)

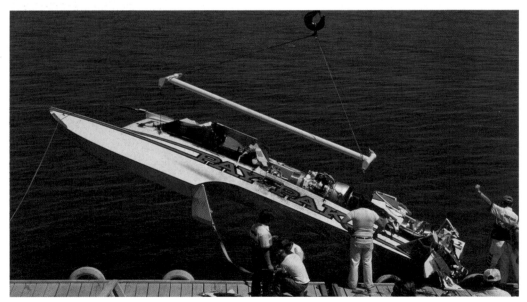

John Walters miraculously escaped serious injury when the *Pay N' Pak* blew over. Considering the ferocity of the accident, the boat survived relatively intact. (Courtesy of Bill Osborne.)

1975–1985: JIM LUCERO

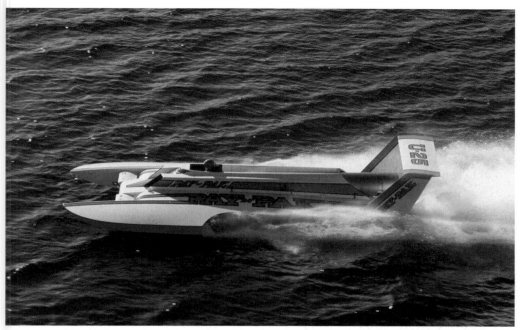

The rebuilt *Pay N' Pak* debuted in 1981 and featured "canard" wings between the sponsons that could be controlled by the driver while the boat was running. (Courtesy of Bill Osborne.)

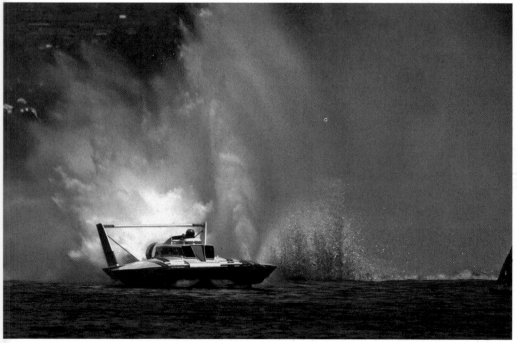

The *Pak* was fast in 1981, claiming second place at the Gold Cup in Seattle, but didn't win a race that year. (Courtesy of Bill Osborne.)

TURBINE RACING IN SEATTLE

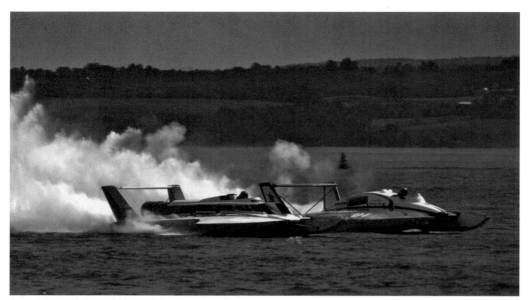

In Syracuse, New York, in 1982, Walters and the *Pak* ran down the Griffon *Bud* from the outside lane to claim the first-ever victory by a turbine hydroplane. (Courtesy of Bill Osborne.)

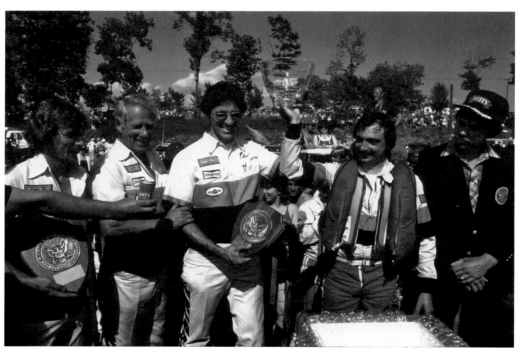

Stan Hanauer (second from left), Jim Lucero (center), and John Walters (second from right) celebrate their victory in Syracuse. (Courtesy of Bill Osborne.)

1975–1985: JIM LUCERO

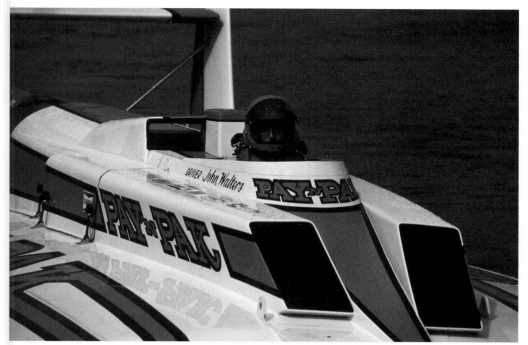

Walters and the *Pay N' Pak* were the second-fastest qualifier at the Seattle race in 1982, clocking in at 138.419, and looked like a force to be reckoned with. (Courtesy of Bill Osborne.)

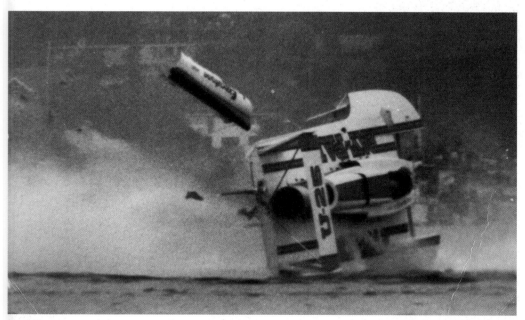

The former *U-95* (now named *Executone*) lost control and veered into the *Pay N' Pak's* path. The *Pay N' Pak* ran over the *Executone* and flipped. Walters was seriously injured and never raced again.

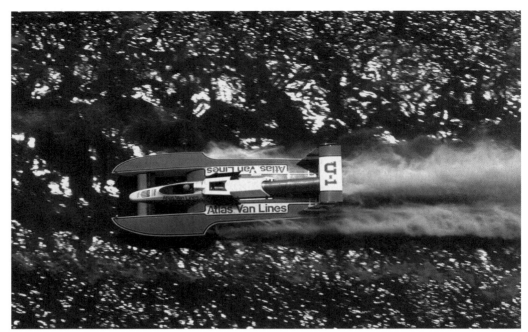

The new *Atlas* missed the first two races of the 1984 season but earned top qualifier in her first race in Evansville, Indiana, turning in a lap of 140.818 miles per hour. (Courtesy of Bill Osborne.)

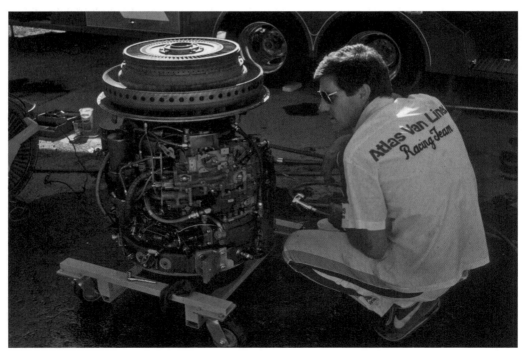

Jim Lucero was truly a man of many talents. He designed boats, built boats, worked on propellers, and, as this photograph shows, worked on motors, too. (Courtesy of Bill Osborne.)

1975–1985: JIM LUCERO

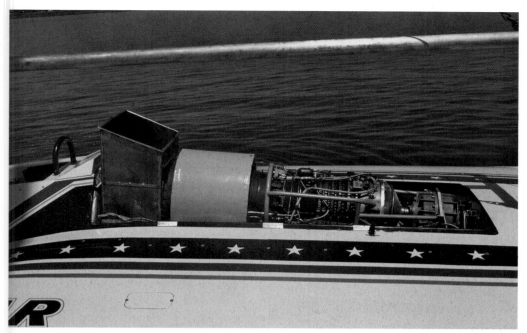

Compared to the Lycoming T-55, the GE T-64 used in the *Lite All Star* was mounted backwards, with the exhaust going straight up behind the cockpit. (Courtesy of Bill Osborne.)

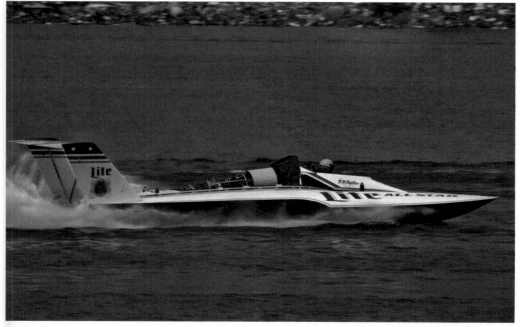

The *Lite All Star* had an experienced crew chief in Jerry Zuvich, a proven driver in Tom D'Eath, and a brand-new Lucero hull with a big-name sponsor, but the team struggled all year and eventually folded. (Courtesy of Bill Osborne.)

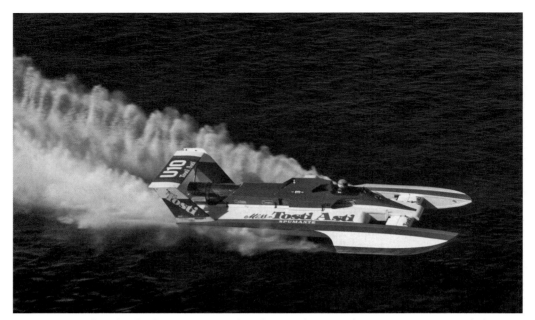

Steve Woomer bought the former *Pay N' Pak* turbine and renamed it *Miss Tosti Asti*. Hard-charging Steve Reynolds, who is driving the boat in the photograph, was hired to drive. (Courtesy of Bill Osborne.)

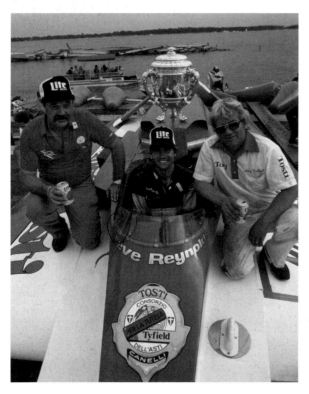

From left to right, Steve Woomer, Steve Reynolds, and crew chief Jerry Verhuel celebrate their victory at the 1984 World Championship race in Houston, Texas. (Courtesy of Bill Osborne.)

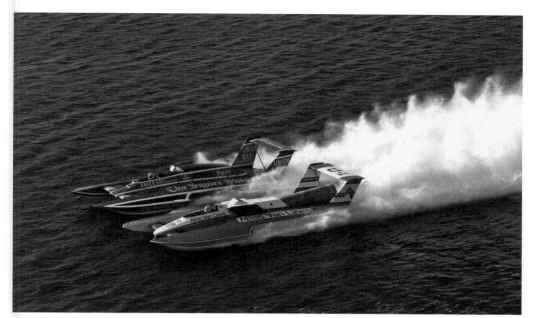

The 1982 and 1983 National Champion *Atlas* was sold to the Squire Shop in 1984. The new turbine *Atlas Van Lines* was very similar in appearance but much faster. (Courtesy of Bill Osborne.).

From left to right, Chip Hanauer, Fran Muncey, and O. H. Frisbie celebrate their third-straight Gold Cup Victory in 1984. Atlas retired from the sport at the end of the 1984 season. (Courtesy of Bill Osborne.)

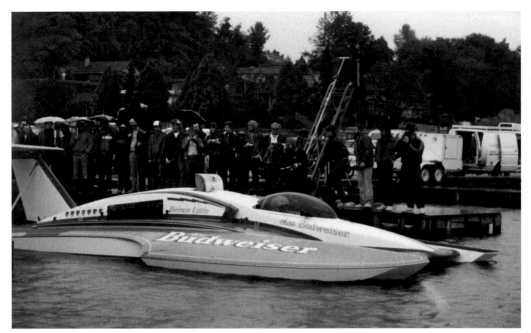

In 1985, Bernie Little and the *Budweiser* team introduced a fully enclosed canopy that featured seat belts and a Plexiglas "bubble" over the driver. Jim Kropfeld is in the boat.

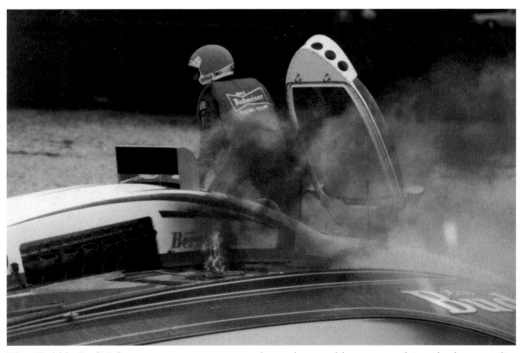

The "Bubble Bud's" first test was a scary one, when a battery blew up, catching the boat on fire before it ever ran.

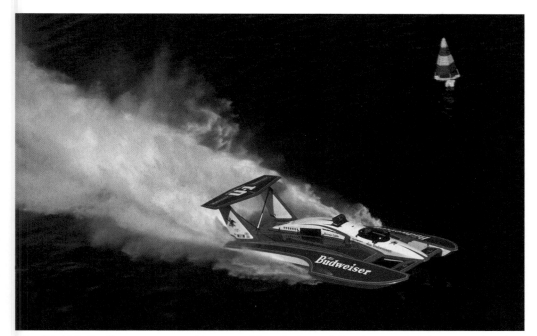

The "Bubble Bud" won races in Syracuse, New York, and San Diego, California, in her first season. (Courtesy of Bill Osborne.)

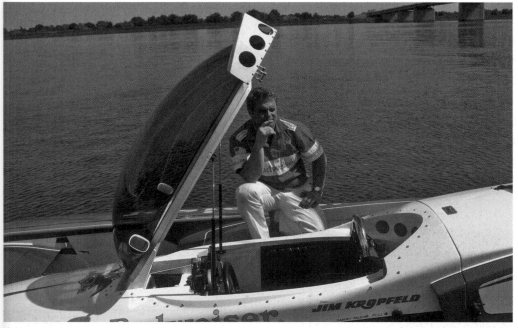

Miss Budweiser crew chief Jeff Neff poses in Tri-Cities with the enclosed canopy that he designed. Neff was Dean Chenoweth's brother-in-law, and when Dean was killed in Tri-Cities in 1982, Jeff vowed to do what he could to make the sport safer. (Courtesy of Bill Osborne.)

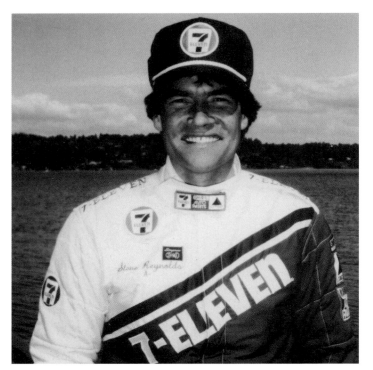

Steve Reynolds, the driver for Steve Woomer's *Miss 7 Eleven*, was handsome, articulate, and popular. (Courtesy of the Southland Corporation.)

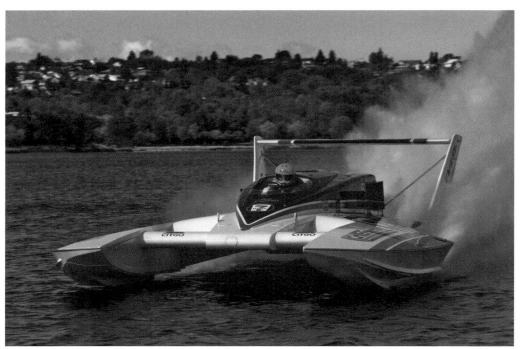

Steve Woomer signed 7 Eleven convenience stores to replace Tosti Asti as his sponsor in 1985. (Courtesy of Bill Osborne.)

Miller Beer was thrilled to have Chip Hanauer driving for them in 1985. He had a flashing smile, movie star good looks, and an uncanny ability to get the most out of every race boat he ever drove. (Courtesy of Miller Beer.)

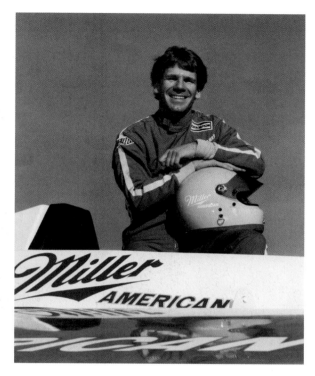

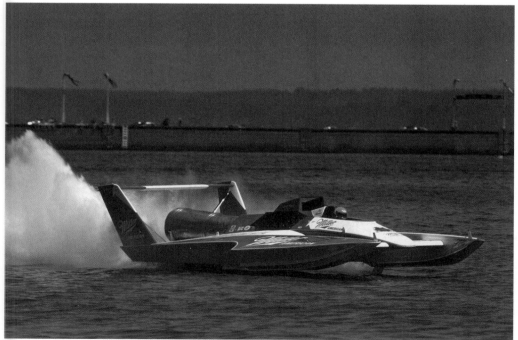

In 1985, the bright red and gold of Miller Beer replaced the blue and white of Atlas Van Lines. (Courtesy of Bill Osborne.)

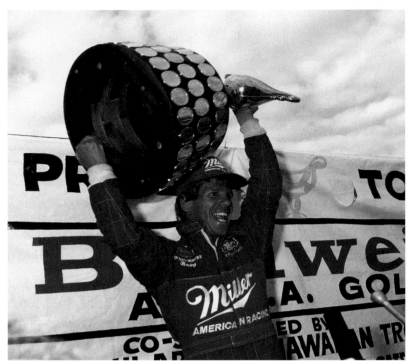

Chip Hanauer drives the *Miller American* to his fourth-straight Gold Cup in Seattle in 1985. (Courtesy of Bill Osborne.)

Here Fran Muncey and Chip Hanauer discuss strategy in Seattle in 1985. (Courtesy of Bill Osborne.)

1975–1985: JIM LUCERO

3

1 9 8 6 — 1 9 9 0

CHIP HANAUER

With just weeks to go before the start of the 1986 season and the new *Miller American* hull far from ready, a frustrated Fran Muncey ended her partnership with Jim Lucero and replaced him as crew chief with former *Pay N' Pak* driver John Walters.

Lucero quickly found a position with Steve Woomer's *Miss 7 Eleven*. The *7 Eleven* was driven by Steve Reynolds.

Bernie Little's Budweiser team ran two boats in 1986, one turbine powered and one Griffon powered. The turbine *Miss Budweiser* was the Lucero-designed former *Lite All Star*, which had been significantly remodeled by Ron Brown. Scott Pierce drove the Griffon and Jim Kropfeld drove the turbine.

Going into the 1986 season, Chip Hanauer was the sport's most successful active driver with 4 consecutive Gold Cup victories, 3 national championships, and 18 race wins. While it was obvious to everyone that Hanauer was a capable and talented driver, there were critics that pointed out that Chip's remarkable string of victories had come while he was driving for Jim Lucero and that perhaps anybody lucky enough to drive for Lucero would have been equally successful. The 1986 season, with Hanauer driving the *Miller* for rookie crew chief John Walters and Jim Lucero preparing the *Miss 7 Eleven* for Steve Reynolds, would quickly settle that debate.

The *Miller* qualified poorly at the first race of the season and had to withdraw, scoring zero points for the day. At the following race, the Gold Cup in Detroit, the *Miller* qualified fastest, won every heat, and gave Chip Hanauer his fifth consecutive Gold Cup. The *Miller* went on to win five out of nine races that year and missed winning the National Championship by a mere 32 points.

Jim Kropfeld adapted easily to the new turbine *Miss Budweiser* and won three races on his way to a National Championship victory. As for the *Miss 7 Eleven*, their best finish all year was a second place in Syracuse, New York.

The year 1987 got off to a rocky start for the *Budweiser* team when they launched their new turbine hull, a design collaboration between veteran boatbuilder Ron Jones and crew chief Ron Brown. The boat was christened with plenty of fanfare and then promptly blew over backwards before ever completing a single lap. Driver Jim Kropfield was unhurt thanks to the new safety canopy. The boat was easily repaired in time to win five of the first six races of 1987.

The same year also saw the unveiling of a new *Miller* that featured a "space-age" enclosed canopy. The boat was quickly nicknamed "The Star Wars Miller." The canopy was the brainchild of project manager Charlie Lyford IV, son of U-95 project manager Chuck Lyford III. The canopy was designed to survive a direct impact with another boat. Hanauer struggled with the new boat

for most of the season before it was replaced with the older, tried-and-true *Miller*. Back in the old boat, Chip won the last two races of the season, including an unprecedented sixth consecutive Gold Cup.

Nineteen eighty-eight was a season of frustration for the Miller team. Fran Muncey had become engaged to veteran limited racer John Prevost. Prevost had secured Circus Circus Casinos to sponsor an unlimited, so Muncey Enterprises fielded a two-boat team, with the 1987 Miller boat running as *Miss Circus Circus* while the 1985 Miller ran as *Miller High Life*. Friction on the team was high as Prevost brought in many new faces and hired his longtime friend Arty Ross to replace the affable and talented John Walters. To make matters more complicated, Prevost elected to drive the *Miss Circus Circus*.

The season got off to a frightening start when the *Bud* and *Pringles* collided in the final heat of the Miami Regatta. Jim Kropfeld hooked in the *Budweiser*, and Scott Pierce in the *Pringles* drove right over the *Bud*'s cockpit. Thanks to the new safety canopies, both drivers survived, but Kropfeld sustained neck injuries that forced him to take some time off. Tom D'Eath filled in for the rest of the season.

In spite of the mounting obstacles, Chip and the Miller team were able to win two races early in the season, including an incredible seventh-straight Gold Cup.

When the boats reached Seattle, a bad situation became worse when an inexperienced Prevost in the *Circus* ran over Mike Hanson in the *Holset Miss Madison* coming back to the pits after heat 2-B. The final straw came in San Diego when Prevost blew the *Circus* over backwards during the run to the start in heat 1-B.

During the off-season, Miller executives became concerned that the *Circus* operation was taking up too much of Muncey Enterprise's time and attention. Miller elected not to renew their contract for 1989.

Fran and Prevost's brief marriage ended with divorce. Fran retired from racing. Bill Bennett of Circus Circus bought all of Muncey's equipment and hired Dave Villwock as crew chief.

While Bennett, Villwock, and Hanauer worked to build their new team, Bernie Little had Ron Brown build a third turbine *Miss Budweiser*, and Steve Woomer signed R. J. Reynolds Tobacco to sponsor his *Winston Eagle*.

Competition in 1989 was fierce, with four different boats winning in the first five races. At the sixth race of the year, in Syracuse, New York, the *Circus* blew over and broke in half. The backup *Circus* was rushed in to service at Tri-Cities but lost its rudder in qualifying. The team limped in to Seattle battered and bruised. Villwock and Hanauer pulled some magic out of their bag and won a sentimental hometown victory.

At the Gold Cup in San Diego, Chip's bid for an eighth consecutive Gold Cup came up short when the *Circus* blew an engine in the final heat.

Miss Budweiser won the National Championship that year, but Chip Hanauer won the Driver's Championship, which *Bud* would have won if they hadn't had to use two different drivers.

In 1990, Villwock and Hanauer won 6 out of 11 races, raised the one-lap time record to 168.128 miles per hour, and claimed Chip's fifth Driver's Championship. At the end of the season, Bill Bennett closed down the *Circus* team and Chip retired.

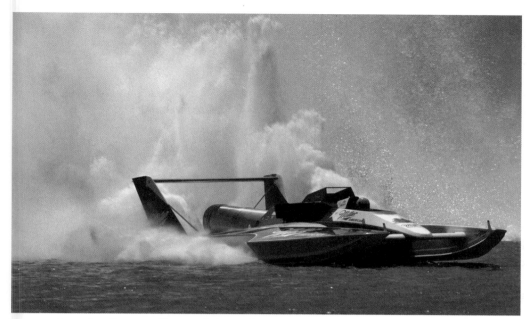

Even without Jim Lucero, Chip and the *Miller* were a formidable team in 1986, winning five races. (Courtesy of Bill Osborne.)

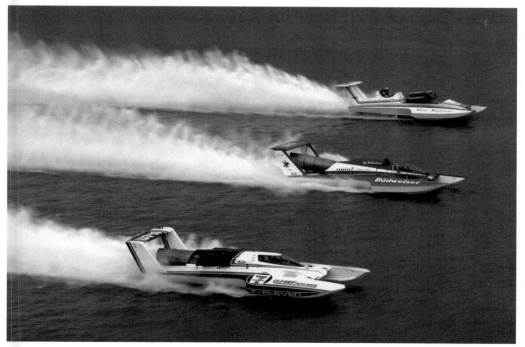

In 1986, there were still several teams running piston boats competitively. In this photograph, turbo-charged, Allison-powered *Miss Madison* keeps up with the *Miss Budweiser* and *Miss 7 Eleven*. (Courtesy of Bill Osborne.)

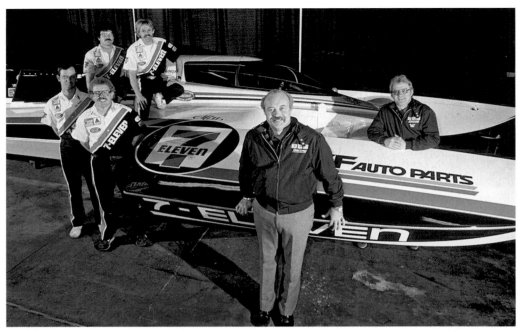

Steve Woomer and the *7 Eleven* crew pose with the newly remodeled *Miss 7 Eleven*. (Courtesy of Bill Osborne.)

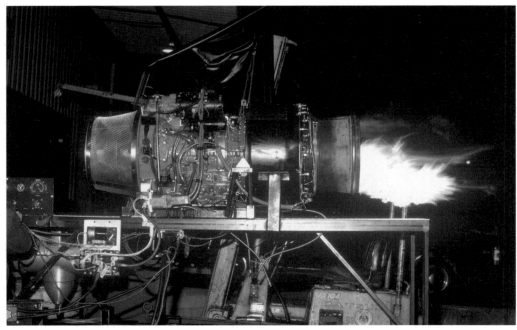

A Lycoming T-55 is an impressive sight, even when it is not in a raceboat. The 7 Eleven team test runs an engine. (Courtesy of Bill Osborne.)

In 1986, *Miss 7 Eleven* sported an enclosed cockpit featuring a canopy from an F-16 fighter jet. Lanky Steve Reynolds looks like he will have a hard time fitting into the tight cockpit. (Courtesy of Bill Osborne.)

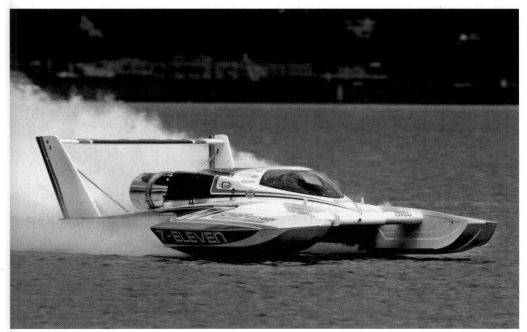

Jim Lucero took over as crew chief of the *Miss 7 Eleven* in 1986. The boat was promising but didn't make it into the winner's circle that year. (Courtesy of Bill Osborne.)

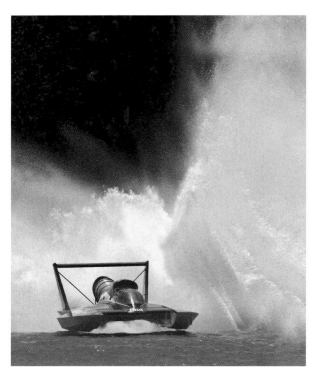

This *Miss Budweiser* turbine hull was actually the former *Miller Lite All Star* that had been built by Jim Lucero. *Budweiser* crew chief Ron Brown made extensive modifications to the hull. (Courtesy of Bill Osborne.)

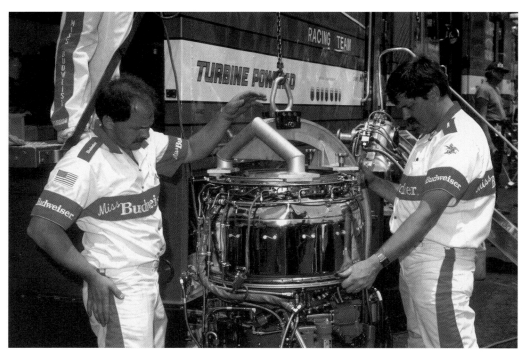

In 1986, hydro crews, who had spent years working on Merlin engines, were just beginning to get the hang of turbines. (Courtesy of Bill Osborne.)

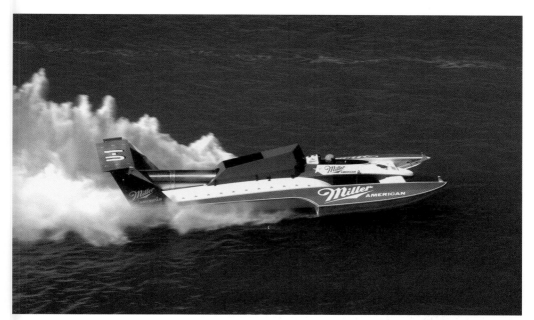

Chip drove the *Miller* to his fifth-straight Gold Cup in Detroit in 1986. (Courtesy of Bill Osborne.)

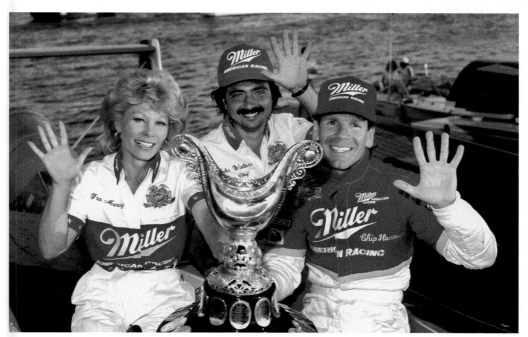

From left to right, Fran Muncie, rookie crew chief John Walters, and Chip Hanauer celebrate their team's fifth consecutive Gold Cup victory. (Courtesy of Bill Osborne.)

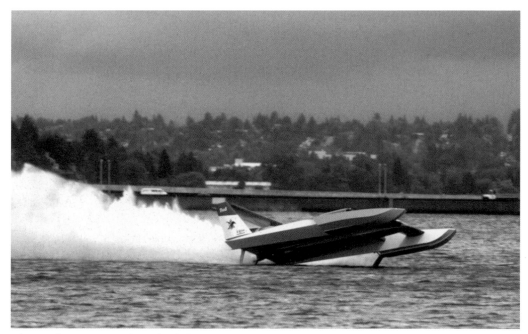

The Budweiser team launched their new *Miss Budweiser* (called *Turbine 2* or *T-2* for short to distinguish it from the previous turbine *Miss Budweiser*) before the start of the 1987 season. The boat had a new enclosed F-16 canopy designed by Ron Jones. Midway through the first lap, at less then 150 miles per hour, the *Miss Budweiser* begins to lift off. (Courtesy of Bill Osborne.)

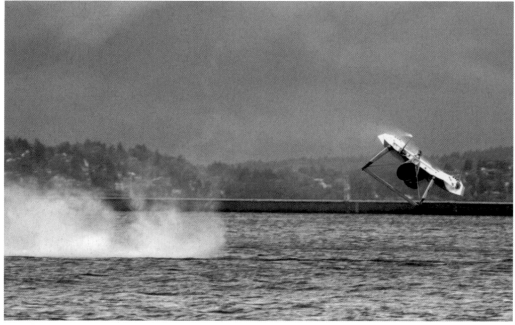

The *Bud* flips completely over! (Courtesy of Bill Osborne.)

1986–1990: CHIP HANAUER

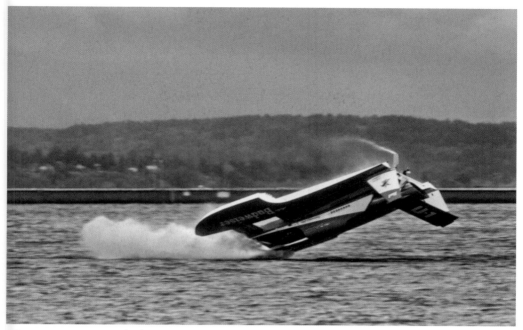

The sponson tips touch the water . . . (Courtesy of Bill Osborne.)

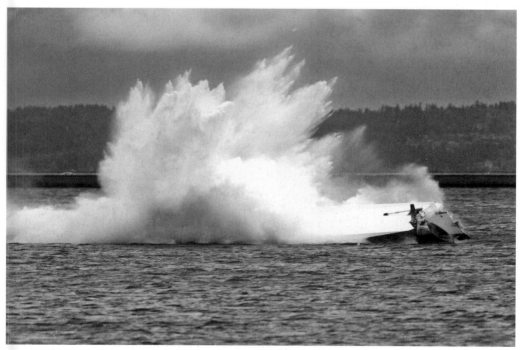

. . . and the boat slams down violently. Luckily the enclosed cockpit worked perfectly, and driver Jim Kropfeld was unhurt. (Courtesy of Bill Osborne.)

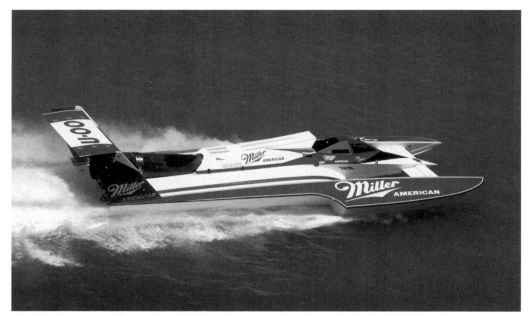

The new *"Star Wars" Miller* hit the water in 1987. It was fast, but midway through the season, the team pulled the new boat and replaced it with the boat they had run previously. (Courtesy of Bill Osborne.)

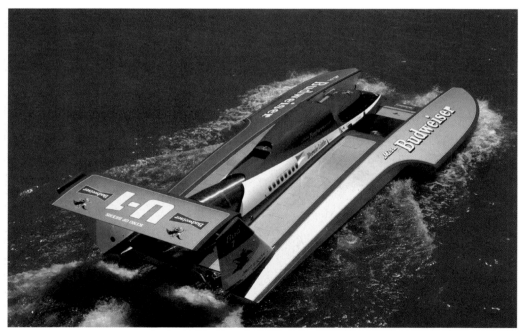

Budweiser got the *T-2* repaired and back on the water in time to win five out of the first six races of the season. Its victory at Miami in 1987 was the first victory by a turbine boat that had not been designed by Jim Lucero. (Courtesy of Bill Osborne.)

1986–1990: CHIP HANAUER

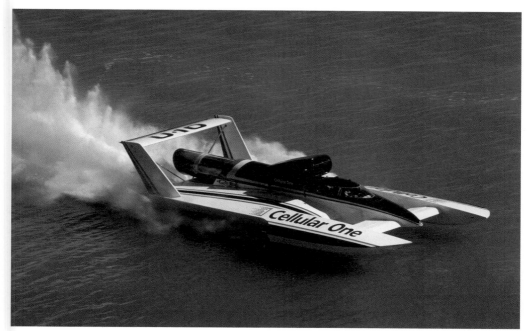

Steve Woomer raced with a new sponsor in 1987, Cellular One. (Courtesy of Bill Osborne.)

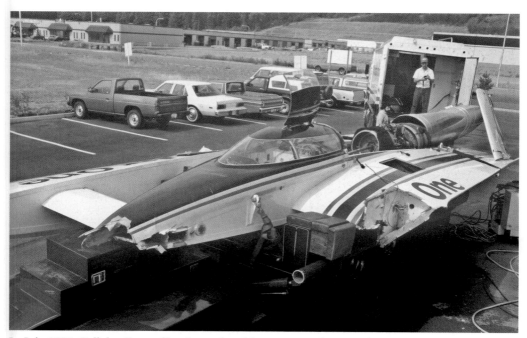

In July 1987, *Cellular One* suffered a violent blow-over crash in Madison. Driver Steve Reynolds was critically injured when his helmet struck the inside of the canopy. Reynolds would recover from his injuries, but he never raced again. (Courtesy of Bill Osborne.)

Muncey Enterprises fielded two boats in 1988. At the start of the season, the old hull was running as *Miller High Life* with Chip Hanauer driving. (Courtesy of Bill Osborne.)

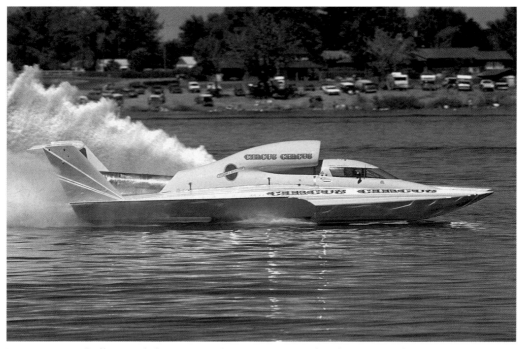

Muncey's new hull started the season as *Circus Circus* with John Prevost driving. By the end of the season, the two boats would switch names and drivers. (Courtesy of Bill Osborne.)

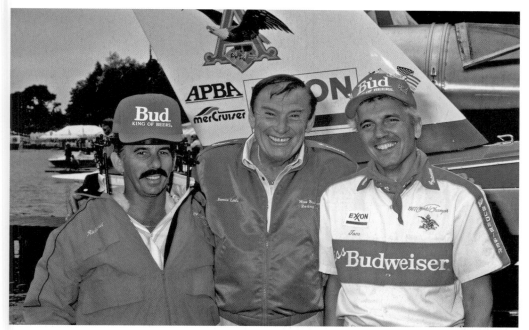

Miss Budweiser had two drivers in 1988. Here Bernie Little stands between Jim Kropfeld (left) and Tom D'Eath (right). Kropfeld started the season driving for Bernie, but injuries suffered in the Miami race necessitated his replacement by Tom D'Eath. (Courtesy of Bill Osborne.)

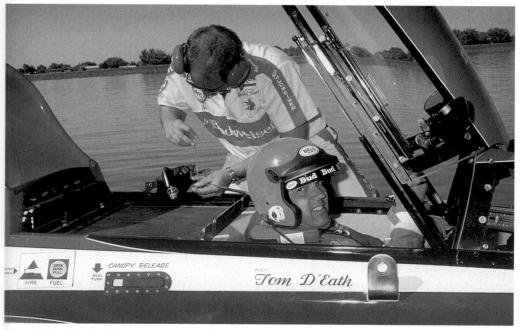

Tom D'Eath helped earn Bernie Little the National Championship in 1988. (Courtesy of Bill Osborne.)

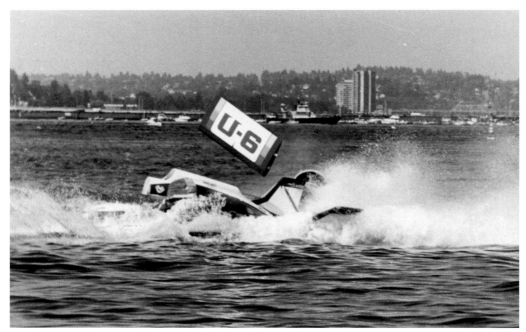

Coming off the racecourse after heat 2-B in Seattle, John Prevost was momentarily blinded by water splashing on his cockpit and ran over the *Holset Miss Madison*. (Courtesy of Bruce Pimental.)

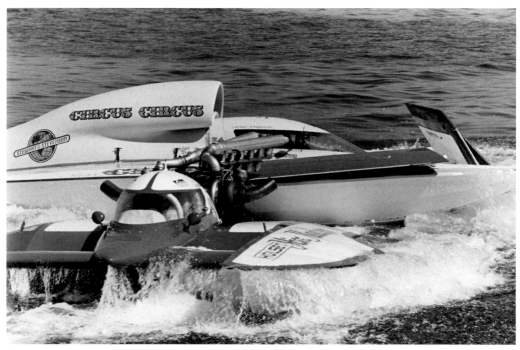

The *Madison* was a brand-new boat, competing in only its second race, when the accident occurred. (Courtesy of Bruce Pimental.)

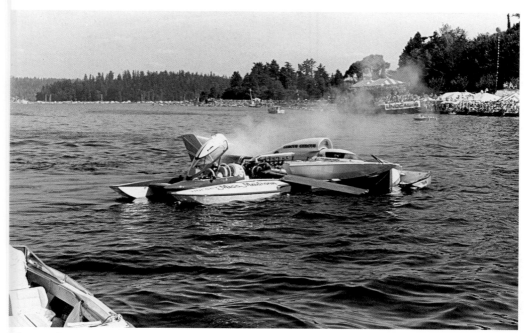

The two boats came to rest a few yards from the pits. (Courtesy of Bruce Pimental.)

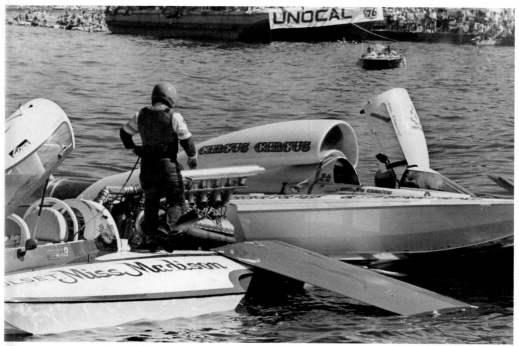

Madison's driver, Mike Hanson, inspects the damage. The *Madison* was badly damaged and was forced to withdraw from the race. The *Circus* was easily repaired and finished third in the final heat. (Courtesy of Bruce Pimental.)

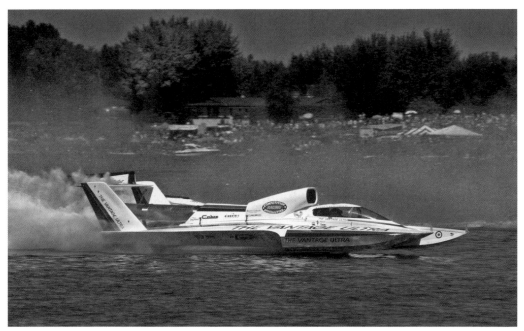

Steve Woomer's team picked up a new sponsor midway through the 1988 season. R. J. Reynolds Tobacco sponsored the *U-10* as the *Vantage Ultra*. (Courtesy of Bill Osborne.)

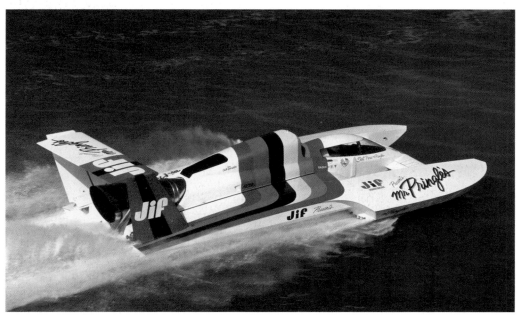

Bill Wurster's *Jif Presents Mr. Pringles* won in Madison in 1988 with Scott Pierce driving. (Courtesy of Bill Osborne.)

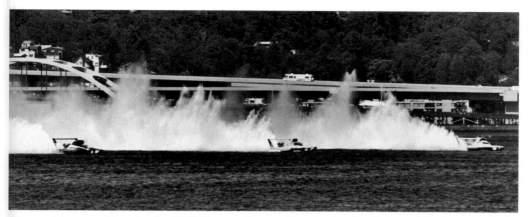

Competition was fierce in the 1989 Rainier Cup in Seattle. In this photograph, Tom D'Eath in the *Miss Budweiser* (left) and Larry Lauterbach in the *Winston Eagle* (center) follow Chip Hanauer in the *Miss Circus Circus* (right) into the first turn of the final heat.

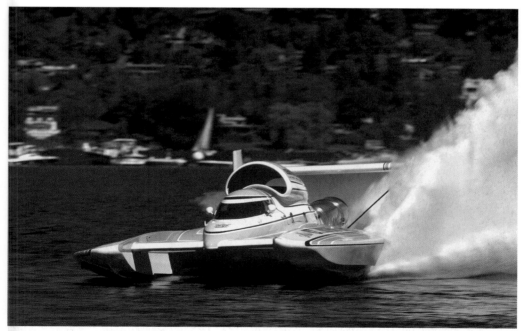

Miss Circus Circus won three races in 1989, including a sentimental victory in Seattle with the backup boat that the team affectionately referred to as "The School Bus." In 1990, they won six races and the National Championship. (Courtesy of Bill Osborne.)

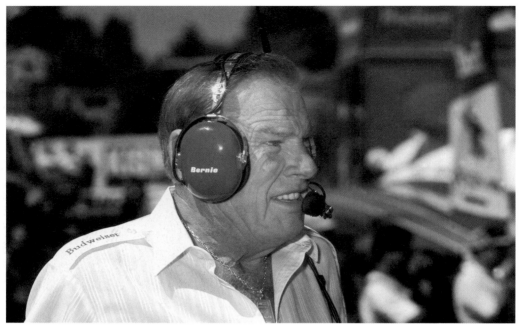

In 1989, Bernie Little and the *Budweiser* won their fourth consecutive National Championship. (Courtesy of Bill Osborne.)

Jim Lucero continued to work for Steve Woomer. Woomer's boat was now sponsored by Winston and was called the *Winston Eagle*. (Courtesy of Bill Osborne.)

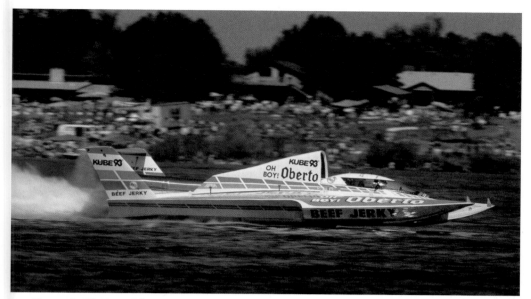

Jim Harvey's *Oh Boy! Oberto* was one of the last teams to run Merlin engines competitively. In 1988, they won two races. In 1989, they were leading the Gold Cup off of the last turn of the last lap, only to be passed by the *Budweiser* a few yards from the finish line. By 1990, the team had switched to turbines. (Courtesy of Bill Osborne.)

Jim Harvey started out as a crewman working for Bob Gilliam in 1966. He worked his way up to become a boat owner by 1987. Even when his sponsorships were not as large as his competitors', his boats were always fast and well prepared. (Courtesy of the Unlimited Racing Commission.)

In 1990, *Miss Circus Circus*, led by Dave Villwock, experimented with a radical three-wing hull designed by Ron Jones Sr. This photograph shows Villwock (standing) and fellow crewman Mark Smith (kneeling) on the deck of the three-wing boat. Smith and Villwock would team up again at Budweiser, where Smith would become crew chief and Villwock the driver. (Courtesy of Stephan Lane.)

The Circus team was proud of it record as an innovator and wasn't afraid to tell the competition what it thought. (Courtesy of Stephan Lane.)

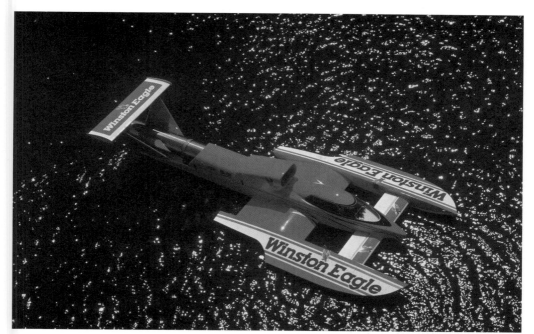

The late 1980s and early 1990s saw a lot of innovation. This unique boat, built for Steve Woomer by Jim Lucero, was called "The Lobster Boat." It was an idea that tested well in smaller models, but the full-size effort was disappointing. (Courtesy of Bill Osborne.)

Here is another view of the *Winston Eagle* "Lobster Boat." (Courtesy of Bill Osborne.)

Longtime racer Chuck Hickling experimented with his Merlin-powered tunnel hull. It never lived up to expectations. (Courtesy of Bill Osborne.)

Throughout the 1980s, boat design continued to evolve. The Budweiser team worked with renowned aerodynamicist Doug Ford to create this multi-wing *Miss Budweiser*. (Courtesy of Doug Ford.)

4

1991–1995

BERNIE LITTLE

No one has had more of an impact on modern unlimited hydroplane racing than Bernie Little. In a career that spanned 40 years, Bernie fielded 23 different *Miss Budweiser* hulls and won 134 races (including 14 Gold Cups) and 22 national championships.

Bernie's life was the classic American success story. He was born October 7, 1926, in rural northwest Ohio in the tiny town of McComb. The population was less than 1,000, and his father ran the local grocery store. The Depression hit McComb hard, and the store closed. Bernie dropped out of school in eighth grade and started working to help the family get by. He shoveled snow, sold newspapers, and did whatever else it took to make ends meet.

At 17, he enlisted in the navy, where he saw action in the Pacific aboard the USS *Marathon*. When he returned from the military, he settled in Florida and began a career selling cars, airplanes, and helicopters. In 1963, Bernie spent an afternoon watching a segment of the television show *Route 66* being filmed. The show featured Guy Lombardo's four-seat unlimited hydroplane, *Tempo*. After the filming, Bernie asked Guy for a ride. Guy agreed, and by the time the day was over, Bernie owned his first unlimited. Bernie, who was born on the seventh day of October and married his wife Jane on the seventh day of January, thought that seven was his lucky number and tried to register his boat as *U-7*, but the number was already taken by Shirley Mendelson's *Notre Dame*, so he settled for keeping Guy's number, *U-13*, on the boat.

Bernie raced the 1963 season without a sponsor, but in 1964, he secured Anheuser-Busch's backing and renamed the boat *Miss Budweiser*. He changed the boat's number to *U-12*, and a dynasty was born.

Bernie never did anything halfway, and once he made up his mind to do something, he threw his heart and soul into it like no one else could.

In the 1960s and 1970s, Bernie and the *Miss Budweiser* were a formidable team that won a number of races, but they didn't dominate the sport. Owners like Lee Schoenith, Ole Bardahl, and Dave Heerensperger were equal to Bernie both on and off the course. Once Schoenith, Bardahl, and Heerensperger left the sport, it fell to Bill Muncey and Muncey Enterprises to act as a counterbalance to Bernie's growing influence. With Bill's death in 1981, the scales began to slip more and more towards Budweiser's domination, but Fran and Chip along with Atlas, Miller, and Circus Circus struggled to keep the sport competitive. Once Muncey Enterprises folded up in 1988 and Circus Circus left in 1990, Bernie was almost unchallengeable on and off the course.

Other teams tried to keep up, but they simply didn't have the resources that Budweiser had. The next best-funded teams—Steve Woomer's *Winston Eagle* and Bill Wurster's *Tide*—had budgets that were never more than one-third of the *Budweiser*'s.

The year 1991 started out with some bad news for the *Miss Budweiser*. Driver Tom D'Eath was seriously injured in a car racing accident. Backup driver Scott Pierce was called in to take over. Mark Tate in the *Winston Eagle* won the Gold Cup in Detroit, but *Budweiser* won four races and the National Championship.

In 1992, Bernie lured Chip Hanauer out of retirement and the scales really tilted in favor of the *Miss Budweiser*. Together Hanauer and Little made a formidable team that won seven out of nine races in 1992, including the Gold Cup and National Championship. One of the few races that the *Bud* didn't win was Seattle's Seafair. Chip was hurt when the *Budweiser* blew over in testing before Seafair, and Scott Pierce was called back to the cockpit on short notice. Pierce did well, making it into the final heat, but victory went to George Woods and the *Tide*.

In 1993, the *Bud*'s domination continued as they won 7 out of 11 races, including the Gold Cup, Seafair, and the National Championship.

The year 1994 got off to a frightening start when the escape hatch in the *Miss Budweiser* inexplicably came open during the Gold Cup in Detroit. The blast of water fractured four vertebrae and forced Chip to miss two races. Mike Hanson took over the driving duties while Chip mended. Mark Tate and the *Smokin' Joe's* won the Gold Cup. Hanson won in Louisville, Texas. Chip came back to win three more races and the National Championship.

The 1995 season saw the *Budweiser* win five races, including the Gold Cup, Seafair, and the National Championship.

Bernie Little's influence over the sport wasn't limited to the racecourse. He also brought Budweiser to the table as a race sponsor, series sponsor, and television sponsor. For example, in 1992, Budweiser sponsored six of the nine races. Eagle Snacks (an Anheuser-Busch brand) was the series sponsor, and Busch's nonalcoholic beer, O'Doul's, sponsored a three-lap shoot-out at the final race of the year in Hawaii. Budweiser was also the sponsor of the 21-station Unlimited Radio Network and all nine races on ESPN Television.

Critics of Bernie Little claim that Anheuser-Busch's heavy involvement in the sport destroyed competition and frightened other sponsors away. Supporters of Bernie Little point out that he poured millions of dollars into the sport and that, without his efforts, several race sites would have been lost.

Whether or not Bernie's domination was good or bad for the sport will be debated for years, but it is an unquestionable fact that Bernie Little loved the sport passionately and devoted a large part of his life (and an even larger part of his bankbook) to unlimited racing.

When Bill Bennett closed down the Circus team at the end of 1990, he sold his equipment to Steve Woomer, including the National Champion boat. This hull, which Lucero had originally built for Fran Muncey in 1986 (and which resulted in his being let go by Muncey) now returned to Lucero. With talented Mark Tate driving, the boat won three races including the Gold Cup. (Courtesy of Bill Osborne.)

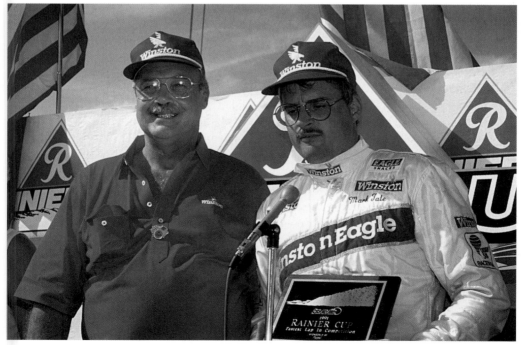

Mark Tate qualified the *Winston* at 152.315 miles per hour and won two heats on the way to a second-place finish in Seattle in 1991.

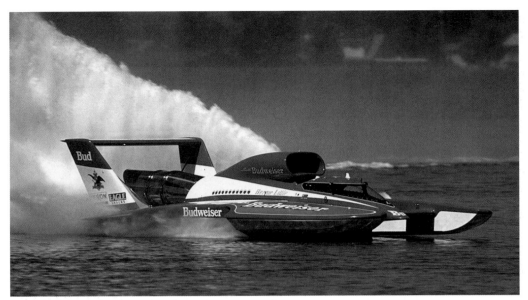

With Scott Pierce driving, the *Miss Budweiser* won four races, including the Seattle Rainier Cup and the National Championship. (Courtesy of Bill Osborne.)

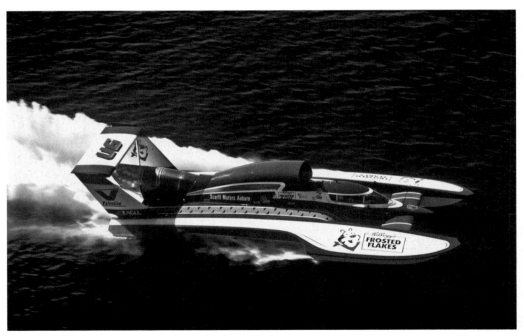

The *Miss Madison* team landed a major sponsor for two races in Washington at the end of the 1991 season. Kellogg's would stay on and sponsor the boat for the entire 1992 and 1993 seasons. (Courtesy of Bill Osborne.)

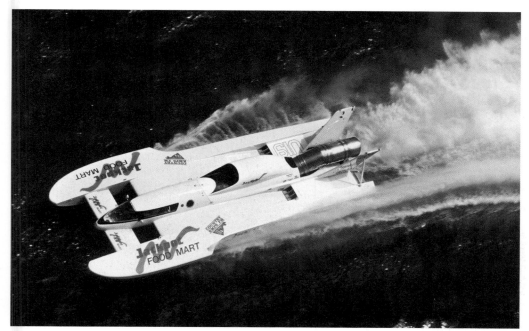

New driver Ken Muscatel earned the Rookie of the Year award driving Bob Fendler's *Jackpot Food Mart*. (Courtesy of Bill Osborne.)

The Ruttkauskas brothers experimented with a twin automotive-powered unlimited sponsored by Edge Shaving Gel. The boat's best finish was an eighth in the Gold Cup with Larry Lauterbach driving. (Courtesy of Bill Osborne.)

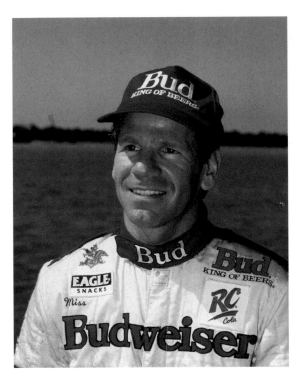

Chip Hanauer returned to unlimited racing in 1992. His decision to drive for Bernie was a difficult one. He knew that having two of the sport's biggest names on the same team might upset the balance of the sport, but he believed that Mark Tate and Jim Lucero, with Winston's support, would provide sufficient counterweight to keep the sport competitive. (Courtesy of Bill Osborne.)

The *Bud* with Chip driving was hard to beat. They won seven out of nine races in 1992, including Chip's eighth Gold Cup to tie him with Bill Muncey for the most Gold Cup victories. (Courtesy of Bill Osborne.)

Bill Wurster is one of the most popular owners in the sport of unlimited racing, and his Seafair victory in 1992 proved that nice guys can finish first. (Courtesy of the Unlimited Racing Commission.)

George Woods drove Bill Wurster's *Tide* to a popular victory in Seattle's 1992 Seafair race. (Courtesy of Bill Osborne.)

The unique multi-wing *Coors Dry* was owned by Ron Jones Jr., son of legendary boatbuilder Ron Jones Sr. and grandson of Ted Jones, the man often credited with inventing the three-point prop riding hydroplane. (Courtesy of Bill Osborne.)

Dave Villwock made a smooth transition from crew chief to driver, winning the first race he entered, San Diego's 1992 Hydrofest. (Courtesy of Bill Osborne.)

One of Bernie Little's strongest values was loyalty, illustrated by his lifelong friendship with broadcaster Jim Hendrick. Bernie and Anheuser-Busch gave Hendrick unflinching support for over 40 years, often in the face of criticism from other teams. Hendrick repaid Bernie's loyalty by making sure that Budweiser always got top value for their sponsorship dollars. (Courtesy of Bill Osborne.)

In 1993, Chip Hanauer and the *Budweiser* continued to rack up race victories, winning 7 out of 10 races and capturing Chip's ninth Gold Cup. (Courtesy of Bill Osborne.)

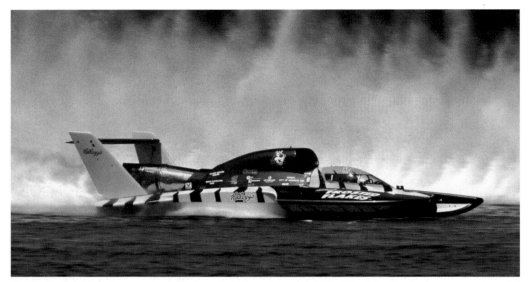

Kellogg's continued to sponsor the *Miss Madison* team in 1993. The blue-and-orange tiger-striped boat was a fan favorite. They were a model of consistency, making it into the final heat in every race of the season, and never finished lower than fourth. They won the San Diego race and finished runner-up to the *Miss Budweiser* in National High Points. (Courtesy of Bill Osborne.)

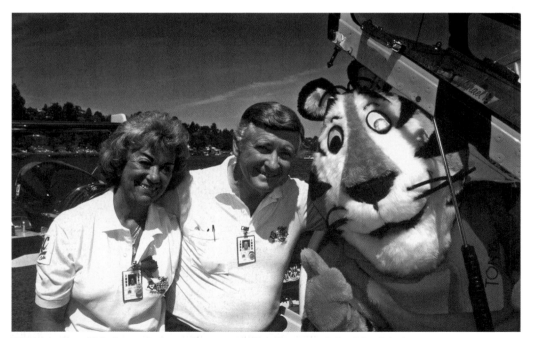

The citizens of Madison, Indiana, have owned and operated the *Miss Madison* racing team since 1961. In 1992, Kellogg's sponsored the boat. Bob and Carol Hughes, the owners' representatives for the City of Madion, are seen here posing in Seattle with their sponsor's mascot. (Courtesy of Bill Osborne.)

In 1991 and 1992, Mark Evans drove Ron Jones Jr.'s *American Spirit*. The *American Spirit* was an innovative sponsor concept developed by Steve Lamson that placed a number of small sponsors onto one boat. In 1993, Mark and the *American Spirit* sponsor concept moved to Fred Leland's team. (Courtesy of Bill Osborne.)

Mark Evans comes from a boat racing family. His father was Norm Evans, who drove famous boats in the 1950s and 1960s like the *Miss Seattle*, *Miss Bardahl*, *Miss Spokane*, and *Miss Eagle Electric*. Mark's brother, Mitch, also drives unlimiteds and was the last driver to win a race with a piston-powered boat. (Courtesy of Bill Osborne.)

In Detroit, the Tate family has been around race boats for as long as anyone can remember. The locals say that no one can get a boat through the tight roostertail turn better then Mark Tate. (Courtesy of Bill Osborne.)

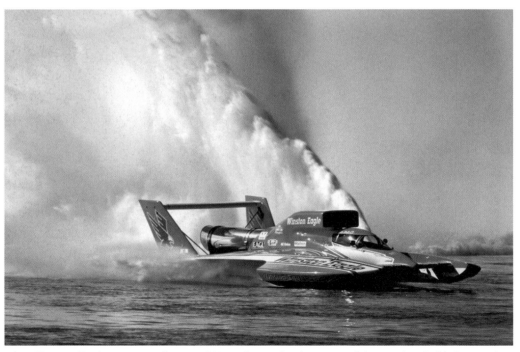

The *Winston Eagle* was very fast in 1993 and was the fastest qualifier at the Gold Cup and in Miami. (Courtesy of Bill Osborne.)

The *Winston Eagle* blew over in the final heat of the Seattle Texaco Cup. Fans were shocked by how high the boat got during its flip. (Courtesy of Bill Osborne.)

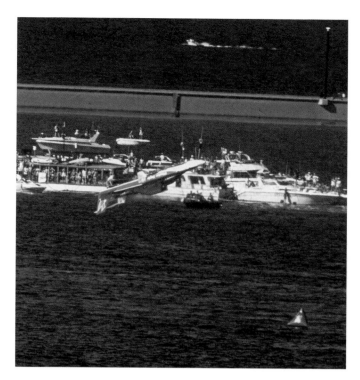

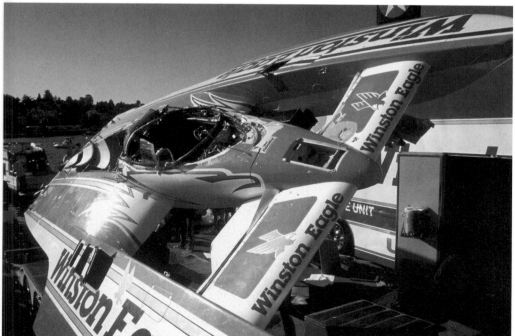

The *Winston*'s safety canopy was badly damaged in the accident, but Mark Tate was not seriously injured. (Courtesy of Bill Osborne.)

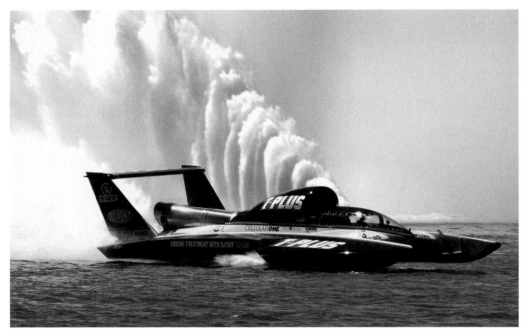

Jim Harvey's new multi-wing *Miss T-Plus* won the final race of the 1993 season in late October in Hawaii with Steve David driving. (Courtesy of Bill Osborne.)

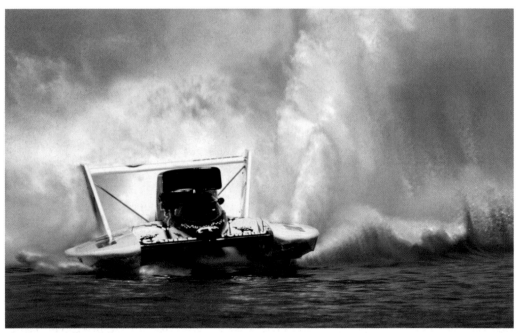

Steve Woomer's boat was sponsored by Camel cigarettes in 1994. They won the first race of the season (the Gold Cup in Detroit) and the last race of the season (the Outrigger Hydrofest in Honolulu, Hawaii). (Courtesy of Bill Osborne.)

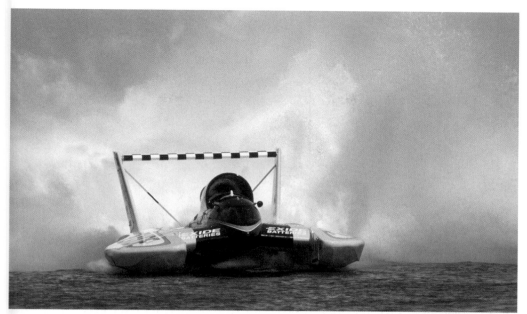

From 1963 to 1965, *Miss Exide* was one of the most popular boats on the unlimited circuit. In 1993, Exide returned to sponsor Brian Keogh's automotive-powered boat for one race. In 1994, Exide returned in a big way with two boats based out of Detroit. (Courtesy of Bill Osborne.)

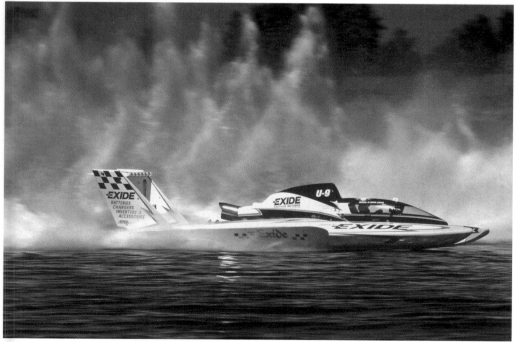

In 1994, *Miss Exide*'s best finish was second place in Seattle with Mark Evans at the wheel. (Courtesy of Bill Osborne.)

In 1994, *Budweiser* won four races in a row and captured the National Championship. (Courtesy of Bill Osborne.)

Budweiser's superior budget allowed the *Budweiser* team to bring two boats to every race, qualify them both, and then select the fastest boat to run on race day. (Courtesy of Stephan Lane.)

1991–1995: BERNIE LITTLE

Glen Davis tried for several years to make his revolutionary reverse four-point design work. In 1994, with support from Ellstrom Manufacturing, the four-point was faster than ever. (Courtesy of Bill Osborne.)

During a last-minute qualifying attempt for the 1994 Seafair race, the *Miss Elam Plus* took off, flew straight up, and then slammed back onto the water, shearing the nose of the boat off and pinning driver Ken Dryden's legs in the cockpit. (Courtesy of Bill Osborne.)

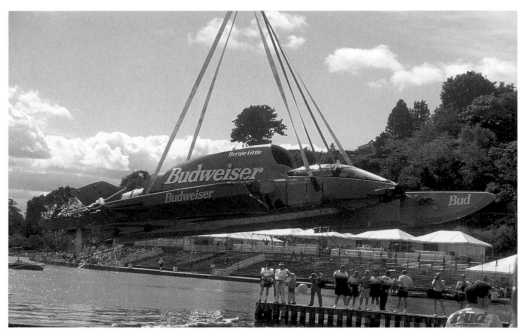

In 1994, Chip Hanauer's "Psychotic Girl Friend" (*Turbine-3*) flipped out for no reason and crashed during testing. Chip came back to drive the *T-2* to a fifth-place finish. (Courtesy of Bill Osborne.)

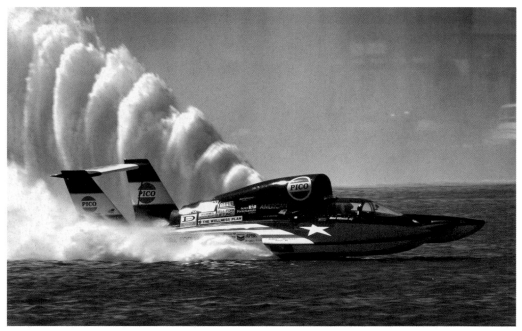

At Seafair in 1994, Dave Villwock won his first race behind the wheel of the *PICO American Dream*. There would be many more to come. (Courtesy of Bill Osborne.)

The multi-talented Mike
Hanson is a boatbuilder,
team manager, and driver.
(Courtesy of Bill Osborne.)

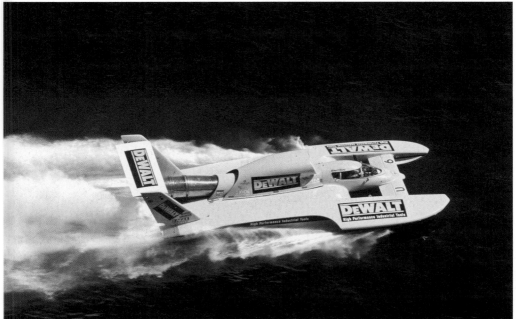

The *Miss Madison* team landed another major sponsor at the end of the 1995 season. Dewalt Tools began a relationship that would last until the end of 1997. (Courtesy of Bill Osborne.)

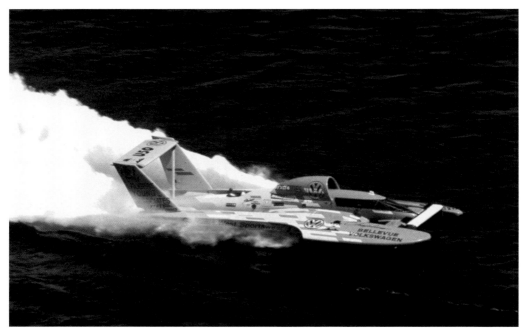

Veteran Scott Pierce returned to racing, driving Ron Jones Jr.'s *U-50* in 1994 and 1995. (Courtesy of Bill Osborne.)

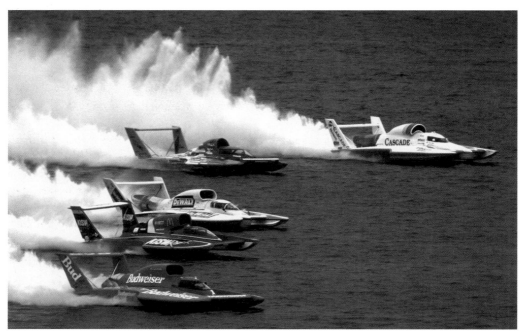

To a casual observer, the 1995 field looked evenly matched, but clearly the *Miss Budweiser* with Chip Hanauer driving was a notch up, winning 5 out of 10 races that year and clinching their fifth-straight National Championship. (Courtesy of Bill Osborne.)

5

1996–1999

DAVE VILLWOCK

In 1996, a new star burst onto the hydro racing scene. Dave Villwock drove the *PICO American Dream* to a Gold Cup victory, a Seafair victory, and four other victories to claim the National Championship. Like so many sports stars, it took 20 years of hard work for Dave to become an overnight success. Villwock began racing Cracker Boxes in 1970 when he was barely 16 years old; by the time he was 20, he was already setting records and winning national championships. He was the national champion in Cracker Boxes in 1974 and 1975. In 1984, he claimed the top spot in three different classes, Super Stock, Ski Runabout, and Pro Comp. He was also inducted into the American Power Boat Association (APBA) Hall of Champions. In 1987, Villwock won the National High Point Championship in a six-liter hydro. In 1988, John Prevost asked Dave to join him on the Circus Circus team. When Prevost left the team in 1989, Villwock stayed to become crew chief. Villwock and Hanauer made a great combination, winning the National Championship in 1990.

In 1992, Villwock teamed up with Ron Jones Jr. to run the new multi-wing *Coors Dry*. Villwock drove the *Coors* at San Diego and became one of only a handful of drivers to win his very first race. The Coors sponsorship folded at the end of 1992, and in 1993, the team returned with Bill Bennett and Circus Circus as a sponsor.

The team was plagued by problems and never lived up to expectations. When Villwock blew over the *Circus* during the one-minute gun in Tri-Cities, a frustrated Bennett pulled the plug again and shut the team down.

In 1994, Villwock went to work for Fred Leland. At Leland's, Villwock was involved with all aspects of the team, including building boats, building propellers, working on the motors, and driving the boat. The team saw major improvements and won in Seattle and San Diego. The team of Leland and Villwock was quickly becoming a force to be reckoned with, but it wasn't fast enough to beat Chip and the *Budweiser* in 1995.

The year 1996 promised to be a struggle between Dave in the *PICO* against Chip in the *Bud*. It didn't turn out that way.

The Budweiser camp was beginning to unravel. In the few years Chip was at Budweiser, he had been involved in more accidents than in all of his prior years of racing. He was frustrated by the accidents because they seemed to happen without warning. Most race boats will give a driver some signs that they are reaching the limits of their performance. In Chip's eyes, the boats were running fine and would just blow over without warning. He even compared the *Miss Budweiser* T-3 to "a psychopathic girl friend" who just flips out without any reason.

Another concern for Chip was that the safety canopy on the *Budweiser* had come apart a few times, losing either the bottom hatch or the lid. Another major doubt was planted in Chip's mind

after a particularly brutal accident in San Diego in 1995. Chip drove the *Miss Budweiser* hard into the first turn of the final heat, and the right sponson collapsed, sending the boat into a horrific cartwheel at 200 miles per hour. Luckily Hanauer was not seriously injured and was able to extricate himself from the damaged boat. He was taken to the hospital for a medical evaluation.

He arrived at the hospital by ambulance wearing his racing uniform, which meant he had no wallet, no cell phone, no credit cards, no money, and no way home. Doctors examined him and found no significant injuries, so Chip waited for someone from the Bud team to come pick him up. No one showed. It got later and later. Chip thought, "The guys must be busy salvaging the damaged boat, they'll come soon." Still no one showed. He spent the night and thought, "Surely someone will come by in the morning." Morning came and still no one from Budweiser showed. Chip called the hotel where the team was staying. He was shocked to learn that they had all checked out and flown back to Seattle. Eventually Chip reached some friends of his that lived in San Diego. They picked him up and drove him back to his hotel, where he was able to get a change of clothes and eventually get home.

In Chip's mind, a good race team functions much like a family. You might disagree and fight, but at the center of it all, you still care about each other. It was becoming clear to Chip that maybe the Budweiser team wasn't a family he wanted to stay part of.

The final straw came in Detroit in 1996, when the *Bud* blew over and landed on top of the *Smokin' Joe's*. Chip went to the Detroit emergency room for an MRI and was shocked that the MRI technicians recognized him and called him by name. He figured, "If I'm getting hurt enough that ER doctors know me by name, it's time to retire." So Chip retired. Mark Evans took over the *Bud* cockpit and won two races, but the championship went to Villwock and *PICO*.

At the end of the season, Bernie Little hired Dave Villwock to be team manager and driver for the *Budweiser*. Ron Brown stayed on as crew chief, but it was a tense situation.

Villwock and the *Bud* swept through the first half of the 1997 season, winning five races in a row. Things got ugly at Tri-Cities. The *Bud* had won all of its elimination heats and was leading the final when she blew over and landed backwards, collapsing the canopy. Villwock was knocked unconscious, and his right hand was severely injured. Rescue personnel were able to revive him, but his badly injured hand became infected and two fingers were amputated.

Skeptics thought Villwock's career was over, but they underestimated him. He returned in 1998 and won eight straight national championships.

Chip Hanauer retired after the *Miss Budweiser* blew over again in Detroit. The canopy failed and gave Chip ample reason to be concerned about his safety. (Courtesy of Bill Osborne.)

Mark Evans filled in for Chip during the 1995 and 1996 seasons. (Courtesy of Stephan Lane.)

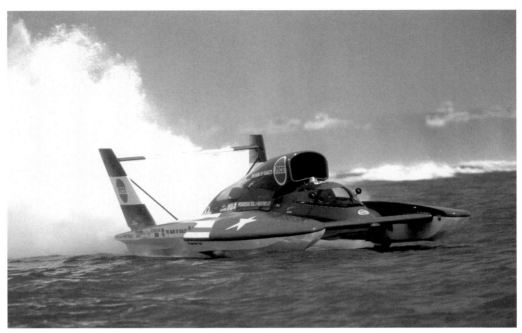

Villwock and the *PICO American Dream* won six races, including the Gold Cup, and broke Bernie Little's stranglehold on the National Championship in 1996. (Courtesy of Bill Osborne.)

Villwock poses with the Gold Cup after his first victory in Detroit in 1996. He would win the trophy four more times, driving for Bernie Little. (Courtesy of Bill Osborne.)

1996–1999: DAVE VILLWOCK

"The Three Kings"—from left to right, Fred Leland, Steve Woomer, and Bernie Little—combined to win over 80 percent of all unlimited races between them during the 1990s. (Courtesy of Ed Clark.)

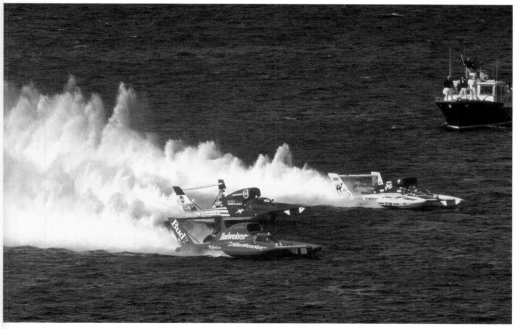

Miss Budweiser, the *PICO American Dream*, and the *Smokin' Joe's* represented the very best that unlimited racing had to offer in the late 1990s. (Courtesy of Bill Osborne.)

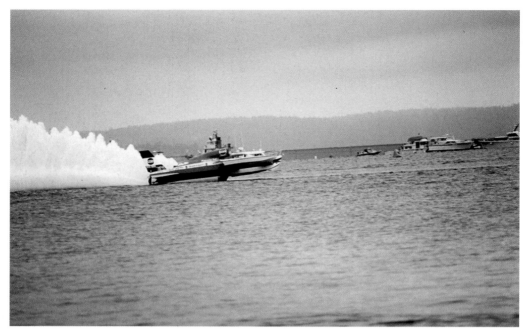

Drivers say, "If you want to run fast, you've got to fly the boat!" Dave Villwock is a master at "flying" his boat, but sometimes even a master can have an accident. The *PICO* starts to lift as it approaches the entrance to the south turn in Seattle in 1996. (Courtesy of Stephan Lane.)

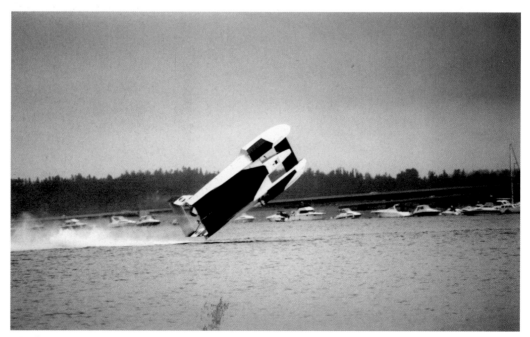

The boat stands on its tail at over 200 miles per hour. (Courtesy of Stephan Lane.)

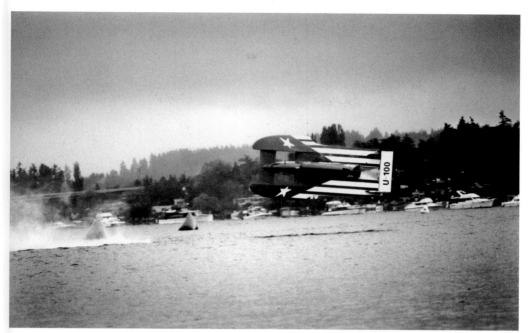

The 6,500-pound *PICO* sails like a child's kite . . . (Courtesy of Stephan Lane.)

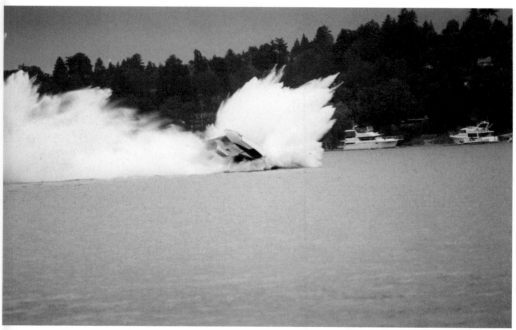

. . . and slams into the water. Villwock was not injured in this qualifying crash and went on to win the race on Sunday. (Courtesy of Stephan Lane.)

The year 1996 saw Seafair take on an international flavor when Australian Ron Burton brought his turbine-powered *Aussie Endeavour* to Seattle. (Courtesy of Bill Osborne.)

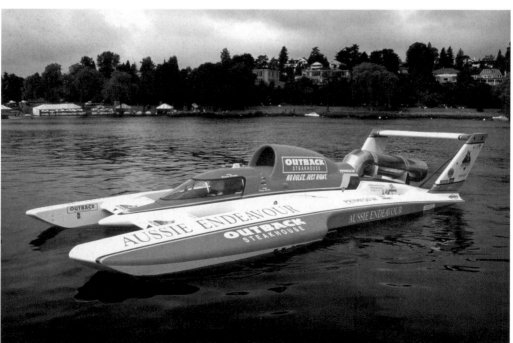

The boat was designed by Ron Jones and was very similar to other Jones multi-wing boats such as the *Coors Dry* or *Miss Circus Circus*. (Courtesy of Bill Osborne.)

The *Aussie* boat was driven
by Dennis Parker. (Courtesy
of Bill Osborne.)

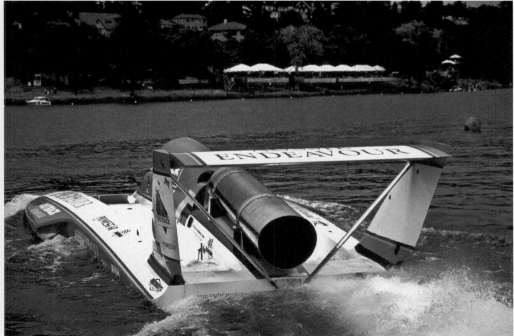

The *Aussie Endeavour* qualified at just over 130 miles per hour and finished sixth in the first heat, but it had to be withdrawn from competition because of damage. (Courtesy of Bill Osborne.)

In 1996, Mike and Lori Jones bought out the failed Exide team and ran both of their boats at Seafair. Lori Jones was the registered owner both boats, making her the first female owner to take part in the sport since Fran Muncey's retirement in 1989. (Courtesy of Bill Osborne.)

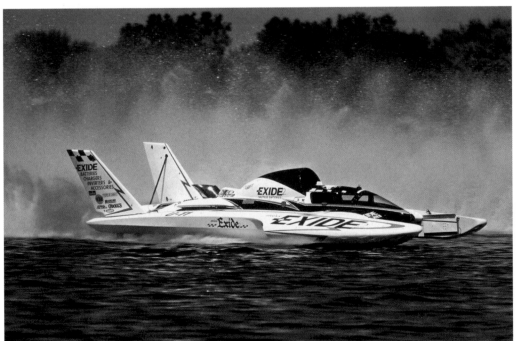

Mike Jones and Mark Weber shared driving duties in the two *Exide* boats. (Courtesy of Bill Osborne.)

1996–1999: DAVE VILLWOCK

In 1997, Bernie Little hired Dave Villwock. Villwock was not just coming in as a driver; he was also taking over as team manager. Villwock and longtime *Miss Budweiser* crew chief Ron Brown tolerated each other in 1997, but Brown eventually left to take a job with Steve Woomer. (Courtesy of Bill Osborne.)

Even though Villwock and *Miss Budweiser* dominated in 1997, winning 6 out of 12 races, the race for second place was always exciting. (Courtesy of Bill Osborne.)

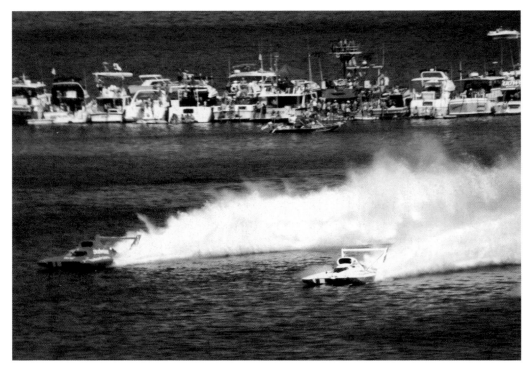

Shortly after this photograph was taken, the *Miss Elam Plus*, being driven by Jim King, took a large bounce and landed on the deck of the *Miss Budweiser*. (Courtesy of Larry Dong.)

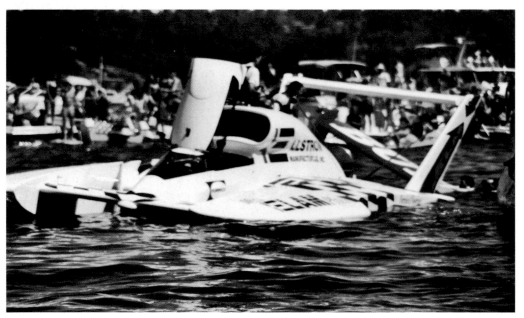

The two tangled boats came to rest just a few yards from Seattle's crowded log boom. Luckily no one was hurt. (Courtesy of Kirk Pagel.)

1996–1999: DAVE VILLWOCK

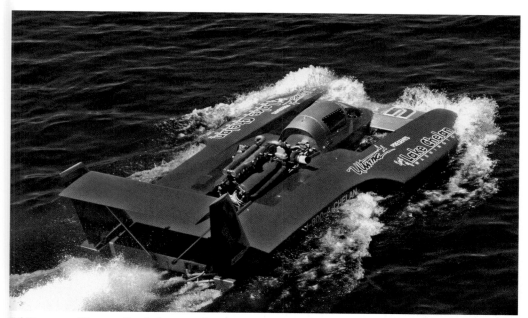

Ed Cooper of Evansville, Indiana, refused to give up on the Allison piston engine. He continued to run successfully against the turbines long after every other piston team had folded. (Courtesy of Bill Osborne.)

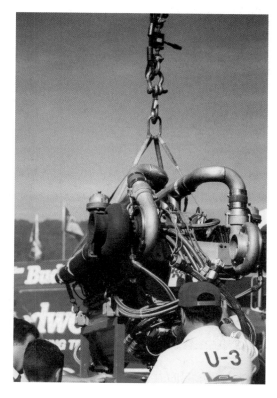

The horsepower output of the 1,710-cubic-inch Allison was dramatically increased by the addition of twin turbo chargers. Ed Cooper is reluctant to say how much horsepower the motor puts out, but gearheads have guessed it to be close to 4,000 horsepower. (Courtesy of Julie Hooton.)

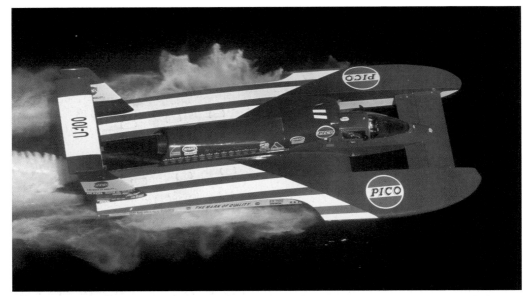

The end of the 1996 season had seen Mark Evans driving *Budweiser* and Dave Villwock driving the *PICO*. In 1997, the roles were reversed with Mark driving the *PICO* and Dave in the *Budweiser*. Mark got caught in some fin water and blew over in the first heat at Seafair. Fred Leland's crew was able to get the boat repaired and back on the racecourse to win the race. The race became know as "Flip and Win!" (Courtesy of Bill Osborne.)

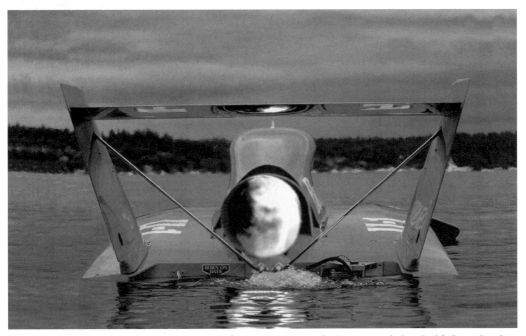

Villwock continued to dominate in 1998, winning 8 out of 10 races and the Gold Cup, Seafair, and the National Championship. (Courtesy of Dean Osborne.)

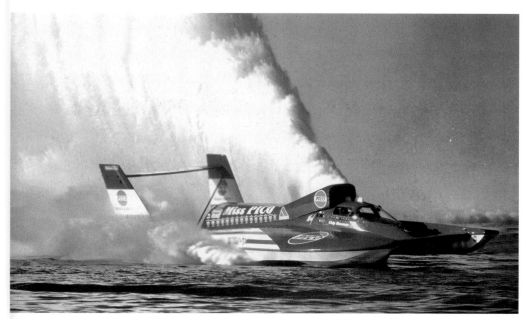

During the latter half of the 1990s, Villwock and the *Miss Budweiser*'s dominance was only challenged once, when Fred Leland talked Chip Hanauer into coming out of retirement one more time to drive the *Miss PICO* in 1999. (Courtesy of Bill Osborne.)

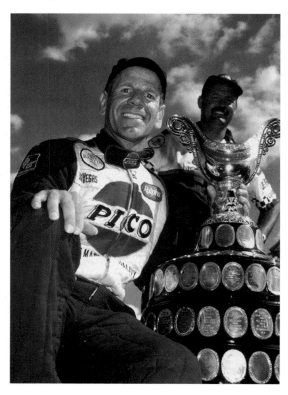

Hanauer won three of the first five races in 1999, including the Gold Cup. Chip, in a move of incredible sportsmanship, elected to retire from racing when his victory total reached 61. Chip's mentor, the late Bill Muncey, held the all-time record for victories with 62 wins. Chip felt that the record should remain with Bill, so he retired rather than claim the record for himself. (Courtesy of Bill Osborne.)

Ken Muscatel is a brilliant and successful psychologist with a passion for racing. His accomplishments on the racecourse have not been as significant as his accomplishments off the racecourse. When the Unlimited Hydroplane Racing Association (UHRA) was nearly bankrupt, Ken took over as commissioner and worked tirelessly for free to return the troubled organization to financial health. (Courtesy of Bill Osborne.)

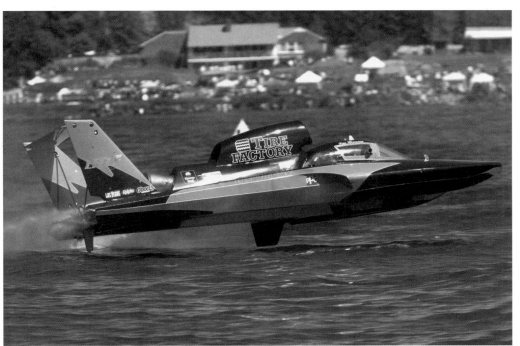

Ken is one of the last owner-drivers left in the sport. In 1999, his *Miss Tire Factory* gave him a wild ride. (Courtesy of Bill Osborne.)

1996–1999: DAVE VILLWOCK

2 0 0 0 – 2 0 0 3

H Y D R O P R O P

In 2000, the action on the racecourse took a back seat to politics. Since the inception of powerboat racing in the early 20th century, the organization that oversaw racing in the United States was the American Power Boat Association (APBA), founded in 1903. The arm of the APBA that oversaw unlimited racing was the Unlimited Racing Commission (URC), formed in 1957. The URC was governed by a board of directors made up of boat owners, drivers, and race site representatives. The board appointed a commissioner whose job was to supervise all aspects of the sport. Eventually the URC changed its name to the Unlimited Hydroplane Racing Association.

By 1998, the UHRA was more than $400,000 in debt. APBA president Steve David asked fellow unlimited driver Ken Muscatel to act as an interim commissioner and resolve the UHRA's debt problems. Muscatel instituted a "temporary" reduction in prize money so that the UHRA could pay down its staggering debt. Under Muscatel's guidance, the UHRA paid off its obligations and became solvent again. Attendance was still dropping and race sites were struggling. At the same time, sponsors continued deserting the unlimiteds for other sports. (A hydro fan strolling through the NASCAR pits would see logos for Winston, Miller, Coors, Tide, Dewalt, Exide, Kellogg's, and many other familiar names that are no longer involved with the hydros.) The 2000 schedule included only seven races, the lowest number in over 20 years.

The APBA watched with growing frustration as attendance at auto racing soared and sponsorship revenues climbed to astronomical levels. Privately owned businesses like CART or NASCAR with a forceful and dynamic owner who had a strong financial incentive to succeed provided a tempting business model.

Bernie Little seemed like a logical candidate to take over the sport; he certainly had the money and he definitely had a huge stake in seeing the sport succeed, but his other business interests wouldn't allow him the time to make the day-to-day decisions involved in running a national sport.

Bernie turned to his longtime friend, outboard and offshore racer Gary Garbrecht, for help. Garbrecht had more than 30 years of experience in boat racing. He started his career with the legendary Carl Kiekhaefer at Mercury Marine in 1964 and was made their director of competition when Mercury decided to use competitive power boating as a development tool. Garbrecht moved his operation to Mercury's famous Lake X, where he hired and mentored many superstars of outboard racing, including Billy Seebold, Bob Herring, and Renato Molinari. When Garbrecht left Mercury, he partnered with Reggie Fountain to develop a line of offshore powerboats. Later he founded his own race team named Second Effort. In 1986, Second Effort raised the world

outboard speed record to 169.53 miles per hour. By 2000, he owned and operated the very successful PROP series for tunnel-hull boats.

Bernie and Garbrecht formed a new business named Hydro Prop and offered to buy the rights to unlimited racing from the APBA. The deal looked good on paper: Garbrecht was going to run the sport, and Bernie would simply be a silent partner providing the capital to get the new business off the ground. The UHRA approved the deal at the race in Evansville and announced it two weeks later at the Gold Cup in Detroit. When Garbrecht took over, he could see that attendance was dropping and he thought he knew why. The *Miss Budweiser* had won 10 races in a row and 25 of the last 38 races. Garbrecht felt that fans simply were not willing to pay money to go to a sporting event where the outcome was so predictable. His first task as owner of Hydro Prop was to slow the *Budweiser* down. It wasn't going to be easy or pleasant.

Villwock and *Budweiser* won seven out of eight races in 2000, including the Gold Cup, Seafair, and the National Championship.

In 2001, Garbrecht used a number of different techniques to slow the *Budweiser* down, including restricting the amount of fuel that the *Bud* could use and mandating lane choice during a race. Hydro Prop's "managed competition" worked, producing five different winners in six races, but it ignited a bitter feud with Dave Villwock. Villwock felt that he was being treated unfairly. He complained loudly in the media, which brought threats and sanctions from Hydro Prop.

After the 2001 season, Garbrecht bought out Bernie's interest in Hydro Prop and became sole owner. In 2002, the *Bud* fared slightly better, winning three out of six races, but the Villwock-Garbrecht feud intensified, fueled in part by the fact that even while Hydro Prop's restriction had increased competition, it had not brought any significant new sponsors to the sport and race sites continued to struggle.

In April 2003, at the age of 77, Bernie Little died of pneumonia. The sport mourned Bernie's passing but also held its breath waiting to see what would happen to the Budweiser sponsorship. The question was not just if they would continue to sponsor the boat, but if they would continue to support the sport. Budweiser was supposed to be title sponsor to half of the races on the 2003 circuit as well as the radio and TV network. Bernie's son, Joe Little, stepped up to take over the racing operation and fulfilled all of Bernie's commitments. The *Bud* only won two races that year but did manage to claim the National Championship for the seventh year in a row.

Animosity between Hydro Prop and the boat owners continued to grow, fueled by the fact that after three years of working with Hydro Prop, there were still no new sponsors and no new race sites. The biggest issue was that the emergency cuts in prize money that Ken Muscatel instituted in 1998 were still in place five years later, long after the debt had been paid off. Some owners suspected that the funds that could be used to restore the prize money were being used to pay Gary and his family large salaries. There was a revolution brewing.

Gary Garbrecht was a lifelong boat racer with a real passion for the sport. Some people feel that a major stroke that Gary had shortly before the start of the 2001 season dramatically affected his plans for Hydro Prop and ultimately led to his selling the organization. (Courtesy of F. Pierce Williams.)

Bernie Little was a pragmatist who understood Garbrecht's need to restore competition, but he wished there was a way to do it through raising the level of his competitors, rather then penalizing the *Miss Budweiser*. (Courtesy of F. Pierce Williams.)

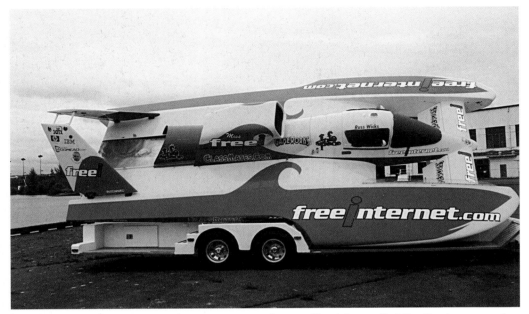

On June 15, 2000, just before the season got underway, Ken Muscatel's *Miss Freei* attempted to break the 38-year-old world water speed record of 200.419 miles per hour held by Roy Duby and the *Miss U.S. 1*. (Courtesy of Karl Pearson.)

The *Miss Freei* had been built by Rick Campbell and members of Muscatel's crew in 1999. The parts for the boat came out of Fred Leland's molds. The world-record effort was spearheaded by Russ Wicks. Wicks had secured funding from a local dot-com company that offered free Internet service. (Courtesy of Karl Pearson.)

2000–2003: HYDRO PROP

Wicks had virtually no experience in driving hydroplanes, but he was trained how to drive by Muscatel and his crew. (Courtesy of Karl Pearson.)

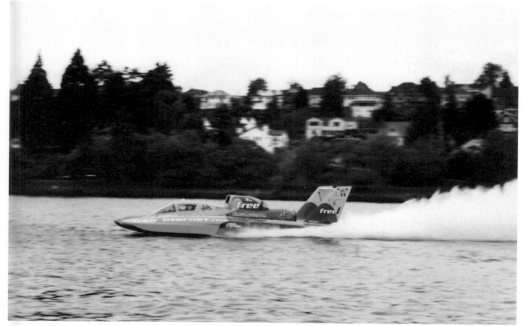

The *Miss Freei* set a new record of 205.494. Critics called the record "A low hanging fruit" because the record was so old, but it is worth pointing out that the last time the *Budweiser* attempted the record, the boat flipped when it lost its rudder and propeller. (Courtesy of Karl Pearson.)

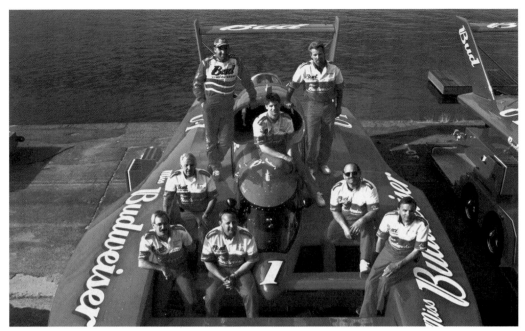

The *Budweiser* enjoyed the tremendous advantage of a large full-time paid crew. The other teams were working with largely volunteer crews. (Courtesy of F. Pierce Williams.)

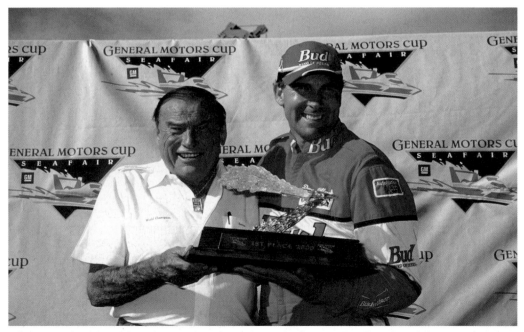

In 2000, as the debate about how to slow down the *Budweiser* raged, Villwock and the *Miss Budweiser* won six out of seven races, including the Gold Cup, Seafair, and the National Championship. (Courtesy of Bill Osborne.)

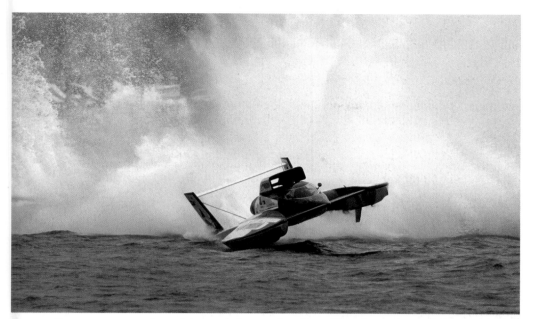

George Stratton was a talented limited driver who drove Kim Gregory's *Wildfire* Unlimited Light. When Gregory announced that Stratton would drive his *U-5 Appian Jeronimo* in 2000, knowledgeable fans expected great things. (Courtesy of Bill Osborne.)

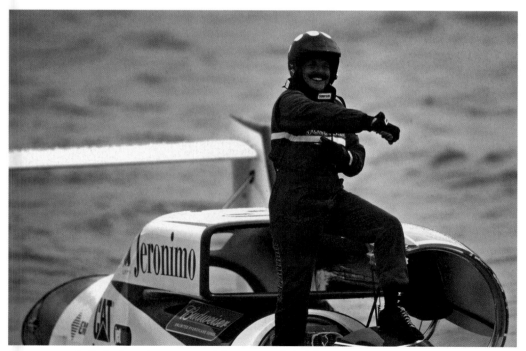

Stratton was killed when the canopy of the *Appian* failed during a crash in San Diego. (Courtesy of Bill Osborne.)

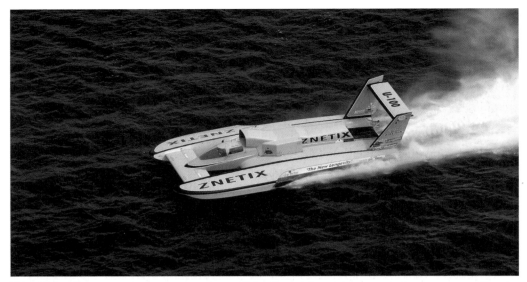

Fred Leland's organization received new life when a large but mysterious sponsor, Znetix, signed on in 2000. The sponsorship lasted two years, with confused fans asking, "What does Znetix sell?" Eventually the Znetix Company was closed down by the Securities and Exchange Commission and the founders arrested for fraud. Fred was left with a large unpaid bill. (Courtesy of F. Pierce Williams.)

Fred hired talented inboard racer Terry Troxell to drive the *Znetix II* boat. Troxell won the 2001 Tri-Cities race. (Courtesy of Bill Osborne.)

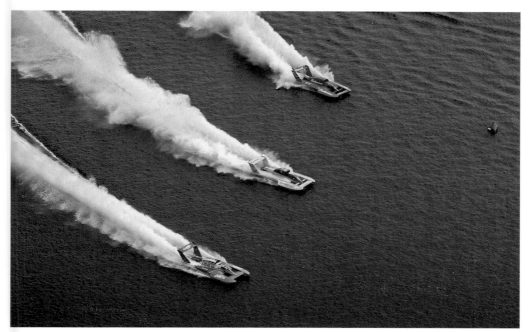

By 2001, Garbrecht's restrictions were producing great competition on the water. There were five different winners in the first five races of 2001. (Courtesy of F. Pierce Williams.)

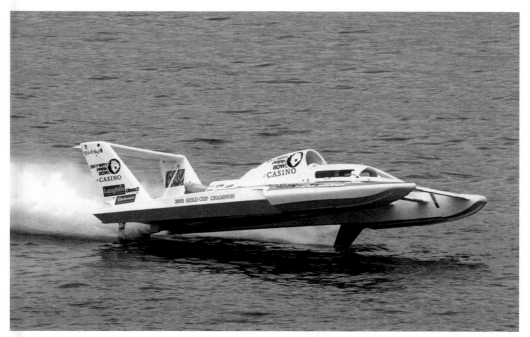

Mike Hanson, driving Mike and Lori Jones's *U-9*, won the Gold Cup. The boat got very light during the Seafair race, but Hanson was able to bring the boat down right side up. (Courtesy of Bill Osborne.)

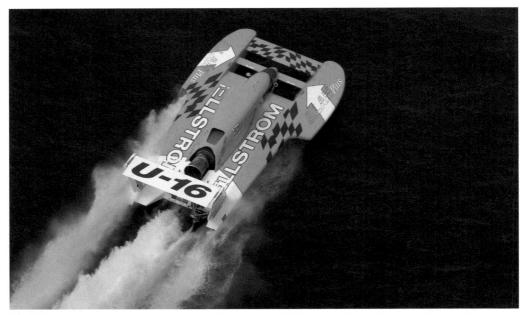

The Ellstrom family entered unlimited racing in 1994 with Glenn Davis's ill-fated four-point hydro. By 2001, they had another boat and were major players in the sport, winning both the Seafair race and the San Diego race. (Courtesy of F. Pierce Williams.)

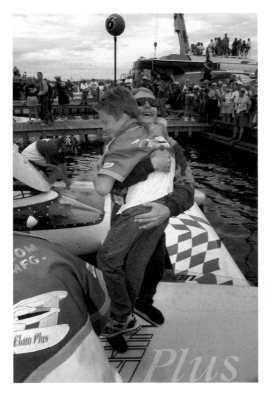

Nate Brown celebrates his 2001 Seafair victory by hugging his son, Derek. (Courtesy of F. Pierce Williams.)

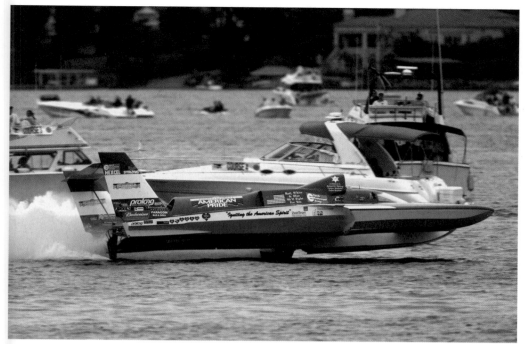

With Znetix out of the picture in 2002, Fred Leland returned to the successful *American Pride* sponsor approach. The boat finished seventh at Seafair with Greg Hopp driving. (Courtesy of Bill Osborne.)

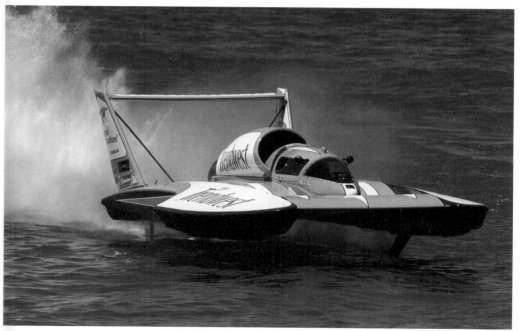

Mark Tate returned to racing in Jim Harvey's *Trendwest*. (Courtesy of Bill Osborne.)

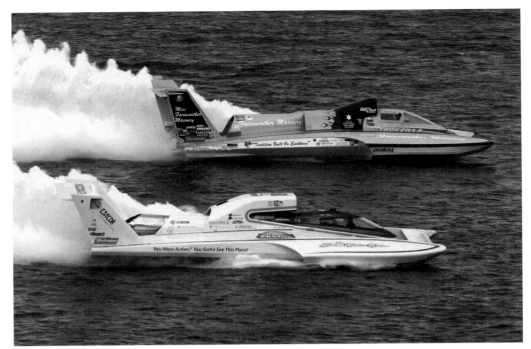

Racing can be a family affair. Here Terry Troxell drives the *Troxilla* against his brother-in-law Mike Weber in the *U-10 Miss Grand Central Casino* at Seafair in 2002. Weber finished sixth and Troxell came in eighth. (Courtesy of Bill Osborne.)

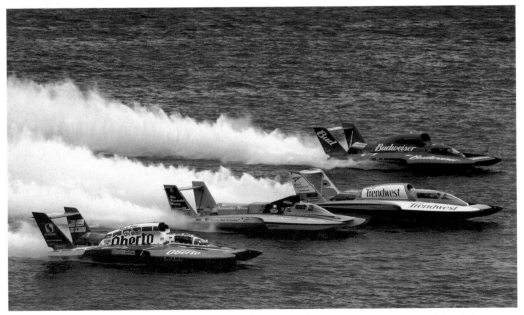

Competition continued to improve under Garbrecht's policy of "managed competition," but some fans felt that they were being deceived. (Courtesy of Bill Osborne.)

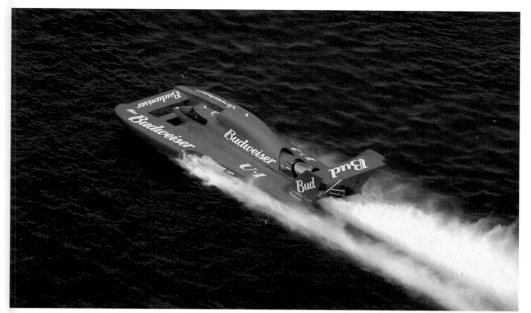

Even with Garbrecht stacking the deck against the *Budweiser*, they still managed to win three out of six races in 2002, including the Gold Cup, Seafair, and the National Championship. (Courtesy of F. Pierce Williams.)

Bernie's victory in Seattle in 2002 would be his last victory ever. He died in the spring of 2003. (Courtesy of Bill Osborne.)

Bernie's son Joe is seen here with Joe Jr. Joe Sr. picked up right were Bernie left off, making sure that the 2003 *Miss Budweiser* was the fastest, best-equipped, and most well-prepared boat in the fleet. (Courtesy of F. Pierce Williams.)

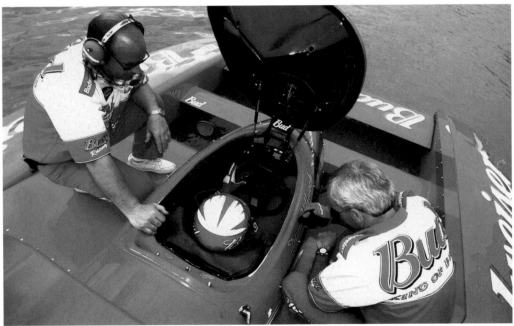

This close-up of the *Miss Budweiser* cockpit shows how far the enclosed canopy had come since the "Bubble Bud" with its Plexiglas lid. (Courtesy of F. Pierce Williams.)

The pits in Seattle can be crowded on race day. (Courtesy of Bill Osborne.)

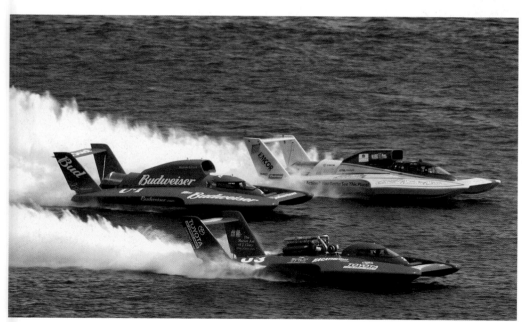

In 2003, the turbine establishment was shocked when Ed Cooper's piston-powered *Fox Hills Chrysler Jeep* won the Gold Cup with Mitch Evans driving. (Courtesy of Bill Osborne.)

TURBINE RACING IN SEATTLE

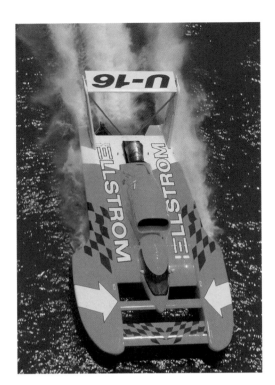

The *Elam* was fast and beautiful in 2003 but struggled to a seventh-place finish in National High Points. (Courtesy of Bill Osborne.)

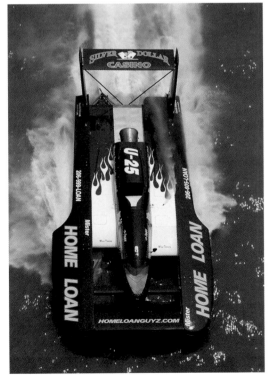

Ken Muscatel continued to fight handling problems with his *U-25*. The boat blew over in the final race of the season in San Diego. (Courtesy of Bill Osborne.)

7

2 0 0 4 – 2 0 0 6

ABRA

At the 2003 awards banquet, Joe Little announced that Budweiser would be leaving the sport at the end of the 2004 season. After 40 years, it was time to go.

The 2004 season got off to an exciting start on March 14, when the *Miss Budweiser* and Dave Villwock set a world record for the kilometer of 220.493 miles per hour at Oroville, California. Villwock had one run clocked at 227.550 miles per hour, the fastest time ever recorded for a propeller-driven boat. Villwock narrowly escaped disaster when the rudder and propeller both sheared off as the boat finished its final run.

The good news of the *Bud* record run was quickly overshadowed by more administrative turmoil involving Hydro Prop. Three race sites—Evansville, Tri-Cities, and San Diego—refused to pay their sanctioning fees unless Hydro Prop would guarantee the number of boats that would appear at their races. The race sites also wanted Hydro Prop to pay a penalty if the guaranteed number of boats didn't materialize. The race sites also wanted to see more prize money going to the boat teams.

Hydro Prop refused to yield, and the three race sites broke away to run their races independently of Hydro Prop and the APBA.

The season was dominated by political turmoil and saw the dispute between Hydro Prop and Budweiser reach the boiling point when *Miss Budweiser* apparently won the 2004 Gold Cup in Detroit. The trophy was awarded, photographs taken, and speeches given, and then almost an hour after the race, Hydro Prop announced that Villwock was disqualified for a lane change during the one-minute period! Nate Brown and the *U-10 Miss DYC* were declared the winner.

In spite of the wrangling, Villwock and the *Miss Budweiser* bowed out in style, winning five out of seven races, including Seafair and the National Championship.

During the off-season, the boat owners and race sites formed a new organization named the American Boat Racing Association (ABRA) to replace Hydro Prop, and for the first time in years, action on the water was not overshadowed by political news.

The season saw four different winners in seven races, but at the end of the day, there was a familiar face atop the winner's podium. Dave Villwock drove *Miss Elam Plus* to victory in San Diego to clinch the National Championship for the *U-16*. Villwock took over driving the *Elam* midway though the season, replacing J. W. Myers after an accident while testing for the Gold Cup.

Steve David, driver of the *Oh Boy! Oberto*, won the Evansville race on his way to capturing the Driver's Championship. Canadian rookie Jean Theoret won races in Seattle and Nashville for Bill Wurster's *Llumar Window Film*. Brand-new owner Dave Bartush won the Gold Cup on his

first try with veteran Terry Troxell in the cockpit of the *Miss Al Deeby Dodge*. The *Miss Al Deeby Dodge* was the oldest boat on the river, having first raced in 1987 as the *Miller American*.

There was lots of exciting news during the off-season between 2005 and 2006. Two-time Gold Cup–winner Billy Schumacher announced that he would buy Bill Wurster's *U-8* race team and return to unlimited racing as an owner. Then Joe Little sold one of his *Miss Budweiser* hydroplanes (*T-3*) to Las Vegas's Kim Gregory. Gregory quickly announced plans to run the full circuit with Nate Brown driving. Next Joe Little sold two more boats (*T-5* and *T-6*) to Ted Porter of Formula Boat Company. Formula has a long history of being involved in powerboat racing. In fact, Formula was founded in 1962 by one of the greatest names in offshore racing, Don Aronow. Porter surprised the unlimited community by committing to running both boats. Mike Weber was hired as team manager and primary driver. Mike Allen, a talented limited driver, was tapped to drive the second boat.

The 2006 season turned out to be as good as advertised, showcasing some of the closest deck-to-deck racing in years. Villwock returned in the *Elam* and won three races. Schumacher's new team won three races, too: the Gold Cup, Seafair, and San Diego. Rookie driver Mike Allen drove the *U-7 Formulaboats.com II* to victory in Valleyfield, Quebec, and placed consistently in all of the other races to earn *Formulaboats.com II* the National High Points Championship. Steve David in the *Oh Boy! Oberto* didn't win a race in 2006 but made it into the final heat in every race and earned himself a second-straight Driver's Championship.

When Bernie Little died in 2003, there were many who felt that unlimited racing would die with him. When Budweiser left at the end of 2004, there were more predictions that the sport would fail. Unlimited racing is now heading into its fifth season without Bernie and its third without Budweiser. Competition, which is the lifeblood of any sport, is at an all-time high.

Powerboat racing has been around since 1904. It has faced some serious challenges during the turbine era, but the thing that has made it so successful for so long is its ability to change and adapt. The sport will continue to evolve over the years ahead, but as long as men have an urge to go fast on water, there will be hydroplane racing.

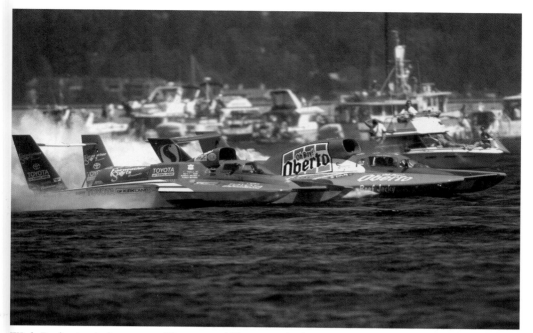

With Budweiser's departure, Oberto would become the longest active sponsor in unlimited hydro racing, going back to 1975. (Courtesy of Bill Osborne.)

In spite of all of the obstacles that Hydro Prop put in Budweiser's way, Villwock and Joe Little won Seafair for the *Budweiser* one final time. (Courtesy of Bill Osborne.)

In 2004, Mark Evans and his wife, Elaine, debuted their four-seat hydro, designed to give rides to media representatives, sponsors, and fans. (Courtesy of Bill Osborne.)

Insurance concerns kept the boat from running much, and eventually the idea was shelved. (Courtesy of Bill Osborne.)

Nate Brown won the 2004 Gold Cup in one of the most controversial races ever. Villwock received the checkered flag as winner of the race. He returned to the dock for a victory celebration. He accepted the trophy, gave his speech, thanked the fans, and returned to the pits to find that he had been penalized for a lane change during the one-minute gun and that the trophy was being awarded to Nate Brown. (Courtesy of Bill Osborne.)

In 2005, Bill Wurster hired Canadian Jean Theoret to drive his *U-8 Llumar Window Film*. Theoret was a newcomer to the unlimiteds but had years of experience driving the fast Grand Prix hydros that are popular in Canada. (Courtesy of Bill Osborne.)

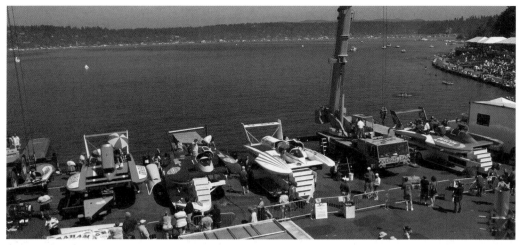

Fred Leland brought three boats (*Miss Lakeridge Paving, Miss Thriftway,* and *Miss Beacon Plumbing*) to the 2005 Seafair race. Fans affectionately refer to Fred's multi-boat team as the "Leland Navy." (Courtesy of Bill Osborne.)

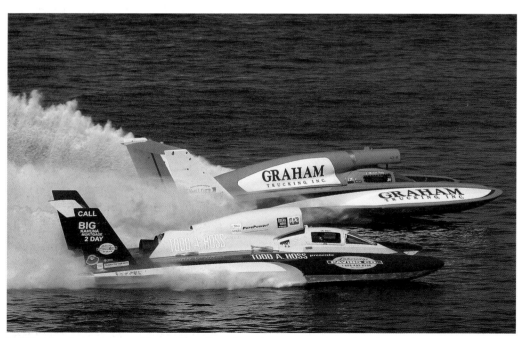

Jeff Bernard, stepson to Terry Troxell and nephew to Mark and Mike Weber, qualified as an unlimited driver in Fred Leland's *Miss Lakeridge Paving.* (Courtesy of Bill Osborne.)

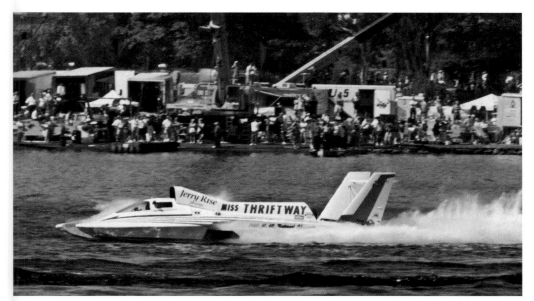

In 2005, the *Miss Thriftway* name returned to the Seafair course for the first time in 42 years. In the 1950s and 1960s, the *Thriftway* won four Gold Cups with Bill Muncey driving. Fred Leland's turbine *Miss Thriftway* with Steve Hook driving failed to score any points. (Courtesy of Ed Clark.)

In one of the most curious events in recent memory, Russ Wicks, holder of the APBA mile world record (205.494 miles per hour), protested outside of the Seafair pits when ABRA failed to offer him a free pit pass. Once Wicks was allowed into the pits, he became involved in a fight with Dave Villwock, holder of the kilometer world record (220.493 miles per hour). Wicks has filed suit against Villwock, and the case is still pending. (Courtesy of Ed Clark.)

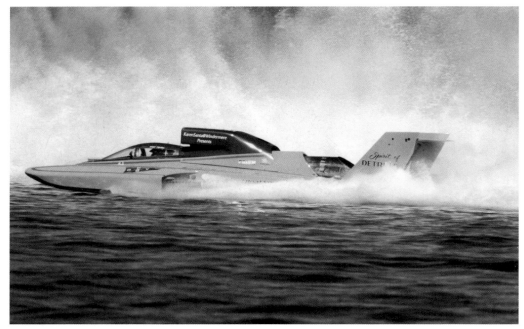

Terry Troxell won the Gold Cup for Dave Bartush in the *U-13 Al Deeby Dodge* in a demolition-derby Gold Cup that saw many of the top contenders sidelined because of damage. It was Bartush's first race as an unlimited owner. (Courtesy of Ed Clark.)

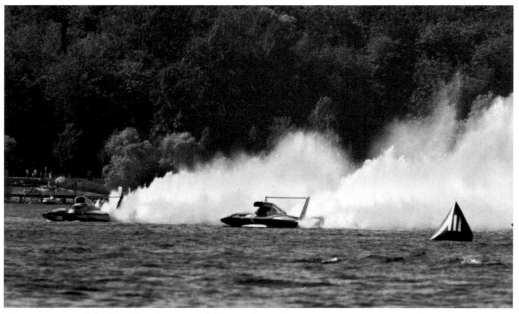

One measure of the health of a sport is the number of young participants. The last few years have seen a tremendous increase in new drivers. Here rookie Jeff Bernard in the *Miss Lakeridge Paving* (left) runs alongside fellow young gun J. Michael Kelly in the *Graham Trucking* (right).

Jean Theoret prepares
for the final heat of the
2005 Seafair in the U-8.
(Courtesy of Bill Osborne.)

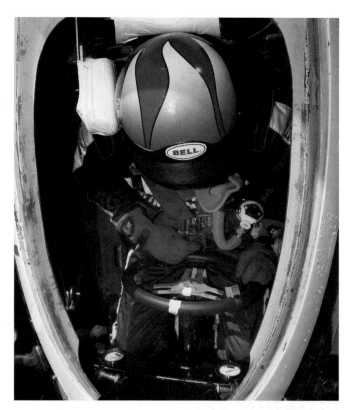

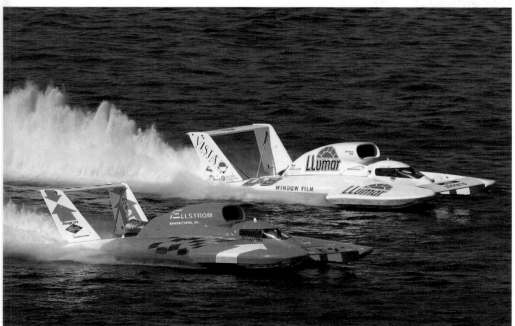

The *Llumar* and *Elam* race for the lead. (Courtesy of Bill Osborne.)

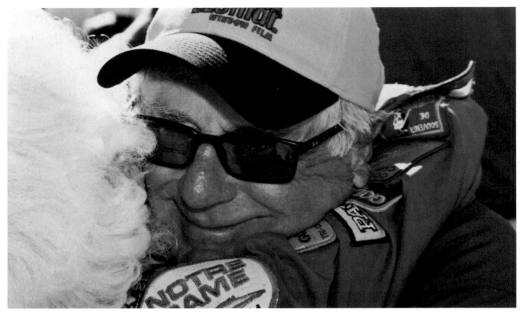

Bill Wurster gets a congratulatory hug from Lucile Woods after his *Llumar Window Film* won the 2005 Chevrolet Cup at Seafair. (Courtesy of Ed Clark.)

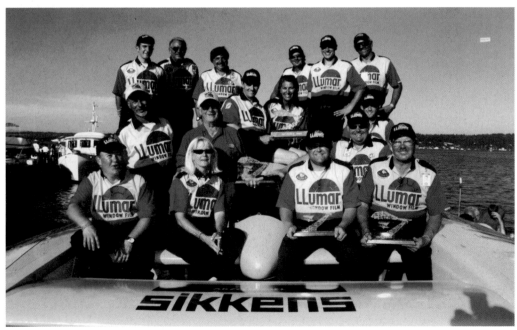

Wurster's *U-8* crew, led by the talented Scott "Pyro" Raney, celebrates their 2005 Seafair victory. After the end of the 2005 season, Wurster would retire from the sport. (Courtesy of Ed Clark.)

In the off-season between 2005 and 2006, Gold Cup winner Terry Troxell had a stroke. He returned to the water for the first time in 2006, driving Fred Leland's *Miss Lakeridge Paving*. (Courtesy of Kirk Johnson.)

Ken Muscatel leased Jim Harvey's *U-2* for the 2006 season. He campaigned it back east as the *Michigan Mortgage* and shared the driving with author David Williams. In the West, Muscatel was the sole driver and the boat ran as *Graham Trucking*. (Courtesy of Kirk Johnson.)

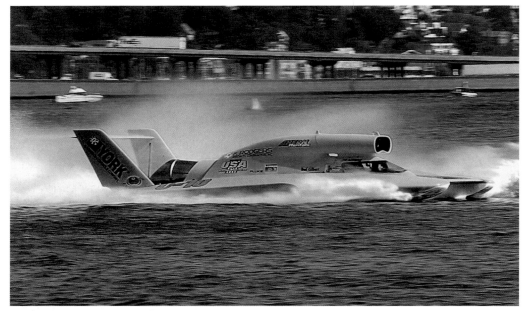

The *Miss Budweiser* legacy lives on in many ways, but none are as obvious as the former *Miss Budweiser*s still racing today. Kim Gregory's *U-10* was built as the *Miss Budweiser T-3*. (Courtesy of Kirk Johnson.)

Billy Schumacher's Gold Cup, Seafair, and San Diego–winning *Miss Beacon Plumbing* started out life as the *Miss Budweiser T-4*. (Courtesy of Kirk Johnson.)

Ted Porter's *Formulaboats.com* was originally the *Miss Budweiser T-6*. (Courtesy of Kirk Johnson.)

Ted Porter's 2006 National Champion *Formulaboats.com II* was the *Miss Budweiser T-5*. (Courtesy of Kirk Johnson.)

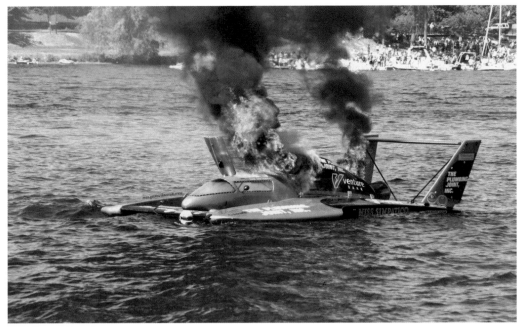

Kevin Aylesworth's *Lucky 21* wasn't so lucky and caught fire during heat 2-B at Seafair 2006. (Courtesy of Patrick Gleason.)

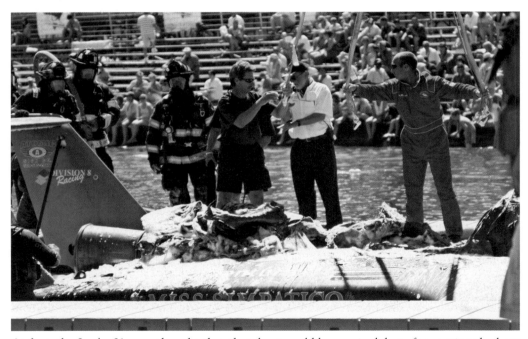

At first, the *Lucky 21* crew thought that their boat could be repaired, but after getting the boat back to their shop in California, they decided to scrap the boat and build a new one for 2007. (Courtesy of Larry Dong.)

2004–2006: ABRA

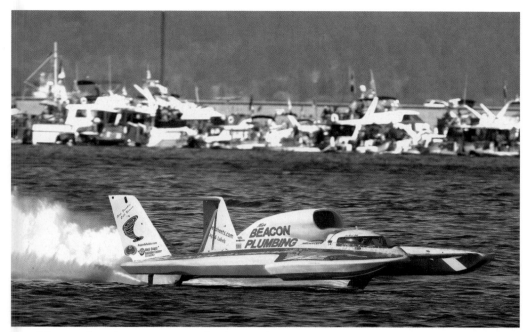

Jean Theoret flies the *Miss Beacon Plumbing* on his way to victory in Seattle for the second year in a row. (Courtesy of Bill Osborne.)

Two-time Gold Cup–winner Billy Schumacher returned to unlimited racing when he and his wife, Jane, purchased Bill Wurster's *U-8* race team. They had a great rookie year, winning the Gold Cup, Seafair, and San Diego. From left to right are Maribel Cahill, Bill Cahill, Bill Schumacher, Jane Schumacher, and Jean Theoret. (Courtesy of Bill Osborne.)

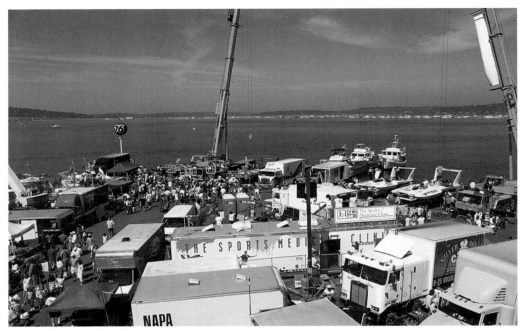

For years, the bright red trucks and trailers of the *Miss Budweiser* dominated the Seattle pits during Seafair. By 2006, the *Budweiser* was gone, but much to the surprise of many critics, fans continued to come and enjoy the racing. (Courtesy of Bill Osborne.)

The Seafair Trophy glistens in the sun on the deck of the *U-37* after their victory in Seattle. This beautiful trophy represents 55 years of hard-fought competition. Hundreds of drivers have risked their lives to win it; only a few dozen have succeeded. For those that have, nothing can compare with the feeling of elation and accomplishment, at least until next summer, when the fans start to flock to the shore and it's time to go racing again. (Courtesy of Ed Clark.)

2004–2006: ABRA

Gold Cup Winners (1985–2006)

Year	Boat	Owner	Driver	Location
1985	Miller American	Fran Muncey	Chip Hanauer	Seattle, WA
1986	Miller American	Fran Muncey	Chip Hanauer	Detroit, MI
1987	Miller American	Fran Muncey	Chip Hanauer	San Diego, CA
1988	Miss Circus Circus	Fran Muncey	J. Prevost/C. Hanauer	Evansville, IN
1989	Miss Budweiser	Bernie Little	Tom D'Eath	San Diego, CA
1990	Miss Budweiser	Bernie Little	Tom D'Eath	Detroit, MI
1991	Winston Eagle	Steve Woomer	Mark Tate	Detroit, MI
1992	Miss Budweiser	Bernie Little	Chip Hanauer	Detroit, MI
1993	Miss Budweiser	Bernie Little	Chip Hanauer	Detroit, MI
1994	Smokin' Joe's	Steve Woomer	Mark Tate	Detroit, MI
1995	Miss Budweiser	Bernie Little	Chip Hanauer	Detroit, MI
1996	PICO American Dream	Fred Leland	Dave Villwock	Detroit, MI
1997	Miss Budweiser	Bernie Little	Dave Villwock	Detroit, MI
1998	Miss Budweiser	Bernie Little	Dave Villwock	Detroit, MI
1999	Miss PICO	Fred Leland	Chip Hanauer	Detroit, MI
2000	Miss Budweiser	Bernie Little	Dave Villwock	Detroit, MI
2001	Tubby's Grilled Submarines	Mike Jones	Mike Hanson	Detroit, MI
2002	Miss Budweiser	Bernie Little	Dave Villwock	Detroit, MI
2003	Fox Hills Chrysler Jeep	Ed Cooper	Mitch Evans	Detroit, MI
2004	Miss DYC	Kim Gregory	Nate Brown	Detroit, MI
2005	Al Deeby Dodge	Dave Bartush	Terry Troxell	Detroit, MI
2006	Miss Beacon Plumbing	Bill and Jane Schumacher	Jean Theoret	Detroit, MI

Seafair Winners (1985–2006)

Year	Boat	Owner	Driver	Race
1985	*Miller American*	Fran Muncey	Chip Hanauer	Gold Cup
1986	*Miller American*	Fran Muncey	Chip Hanauer	Emerald Cup
1987	*Miss Budweiser*	Bernie Little	Jim Kropfeld	Budweiser Cup
1988	*Miss Budweiser*	Bernie Little	Tom D'Eath	Budweiser Cup
1989	*Miss Circus Circus*	Bill Bennett	Chip Hanauer	Rainier Cup
1990	*Miss Circus Circus*	Bill Bennett	Chip Hanauer	Rainier Cup
1991	*Miss Budweiser*	Bernie Little	Scott Pierce	Rainier Cup
1992	*The Tide*	Bill Wurster	George Woods Jr.	Rainier Cup
1993	*Miss Budweiser*	Bernie Little	Chip Hanauer	Texaco Cup
1994	*PICO American Dream*	Fred Leland	Dave Villwock	Texaco Cup
1995	*Miss Budweiser*	Bernie Little	Chip Hanauer	Texaco Cup
1996	*PICO American Dream*	Fred Leland	Dave Villwock	Texaco Cup
1997	*PICO American Dream*	Fred Leland	Mark Evans	Texaco Cup
1998	*Miss Budweiser*	Bernie Little	Dave Villwock	Texaco Cup
1999	*Miss Budweiser*	Bernie Little	Dave Villwock	General Motors Cup
2000	*Miss Budweiser*	Bernie Little	Dave Villwock	General Motors Cup
2001	*Miss Elam Plus*	Ellstrom Mfg..	Nate Brown	General Motors Cup
2002	*Miss Budweiser*	Bernie Little	Dave Villwock	General Motors Cup
2003	*Miss Budweiser*	Joe Little	Dave Villwock	General Motors Cup
2004	*Miss Budweiser*	Joe Little	Dave Villwock	General Motors Cup
2005	*Llumar Window Film*	Bill Wurster	Jean Theoret	Chevrolet Cup
2006	*Miss Beacon Plumbing*	Bill and Jane Schumacher	Jean Theoret	Chevrolet Cup

NATIONAL CHAMPIONS (1985–2006)

Year	Boat	Owner	Driver
1985	*Miller American*	Fran Muncey	Chip Hanauer
1986	*Miss Budweiser*	Bernie Little	Jim Kropfeld
1987	*Miss Budweiser*	Bernie Little	Jim Kropfeld
1988	*Miss Budweiser*	Bernie Little	Tom D'Eath
1989*	*Miss Budweiser*	Bernie Little	Tom D'Eath
1990	*Miss Circus Circus*	Bill Bennett	Chip Hanauer
1991*	*Miss Budweiser*	Bernie Little	Scott Pierce
1992	*Miss Budweiser*	Bernie Little	Chip Hanauer
1993	*Miss Budweiser*	Bernie Little	Chip Hanauer
1994*	*Miss Budweiser*	Bernie Little	C. Hanauer/M. Hanson
1995*	*Miss Budweiser*	Bernie Little	C.Hanauer/Mark Evans
1996	*PICO American Dream*	Fred Leland	Dave Villwock
1997*	*Miss Budweiser*	Bernie Little	D. Villwock/Mark Weber
1998	*Miss Budweiser*	Bernie Little	Dave Villwock
1999	*Miss Budweiser*	Bernie Little	Dave Villwock
2000	*Miss Budweiser*	Bernie Little	Dave Villwock
2001	*Miss Budweiser*	Bernie Little	Dave Villwock
2002	*Miss Budweiser*	Bernie Little	Dave Villwock
2003	*Miss Budweiser*	Joe Little	Dave Villwock
2004	*Miss Budweiser*	Joe Little	Dave Villwock
2005*	*Miss Elam Plus*	Ellstrom Mfg.	J. W. Myers/D. Villwock
2006*	*Formulaboats.com II*	Ted Porter	Mike Allen

*There were a number of years when the National Champion Driver was not the driver of the National Champion Boat. In 1989, Chip Hanauer was the Driver's Champion; in 1991, Mark Tate won the Driver's Championship; in 1994 and 1995, it was Mark Tate again. Tate won again in 1997. Steve David won in 2005 and 2006.

ACROSS AMERICA, PEOPLE ARE DISCOVERING SOMETHING WONDERFUL. *THEIR HERITAGE.*

Arcadia Publishing is the leading local history publisher in the United States. With more than 3,000 titles in print and hundreds of new titles released every year, Arcadia has extensive specialized experience chronicling the history of communities and celebrating America's hidden stories, bringing to life the people, places, and events from the past. To discover the history of other communities across the nation, please visit:

www.arcadiapublishing.com

Customized search tools allow you to find regional history books about the town where you grew up, the cities where your friends and family live, the town where your parents met, or even that retirement spot you've been dreaming about.